THE ART OF
ZENTANGLE®

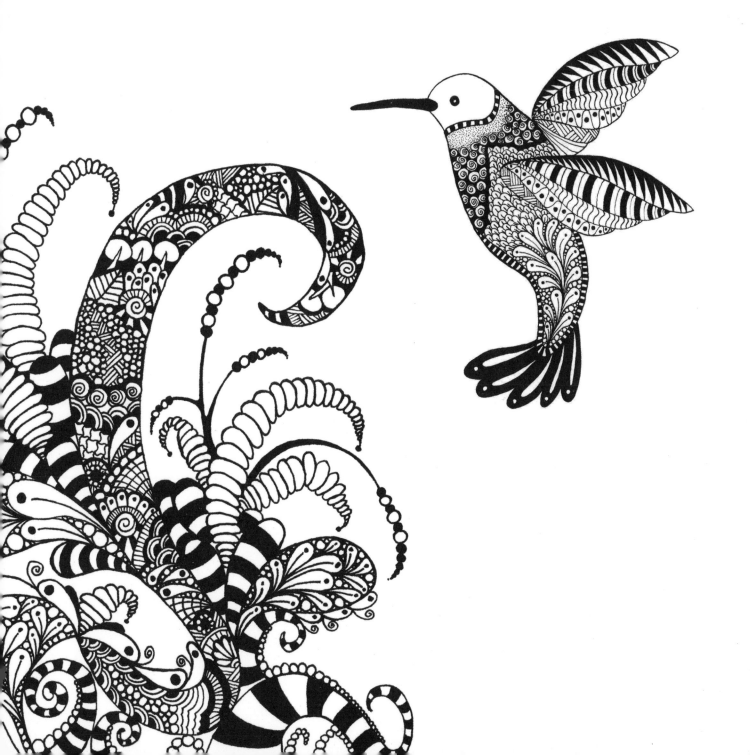

Q Quarto Knows

Quarto is the authority on a wide range of topics.
Quarto educates, entertains and enriches the lives of our readers—
enthusiasts and lovers of hands-on living.
www.quartoknows.com

© 2013 Quarto Publishing Group USA Inc.
Published by Walter Foster Publishing, a division of Quarto Publishing Group USA Inc.
All rights reserved. Walter Foster is a registered trademark.
Artwork on pages 1, 7, 12–53 © 2013 Penny Raile, CZT. Artwork/photographs on
pages 6, 120–142 © 2013 Lara Williams, CZT. Artwork on page 10 © 2009 Eileen F.
Sorg. Artwork on pages 11, 56–87 © 2013 Norma J. Burnell, CZT. Artwork on pages
11 ("Dewdrop"), 90–111, 117–119 © 2013 Margaret Bremner, CZT.
Photographs on pages 114–116 © 2013 WFP.

Walter Foster

6 Orchard Road, Suite 100
Lake Forest, CA 92630
quartoknows.com
Visit our blogs @quartoknows.com

Printed in China
15 17 19 20 18 16

THE ART OF
ZENTANGLE®

50 inspiring drawings, designs & ideas for the meditative artist

TABLE OF CONTENTS

INTRODUCTION TO ZENTANGLE®

Developed by Rick Roberts and Maria Thomas, Zentangle® is a fun, contemplative, relaxing art form that employs structured and coordinated patterns as a means of creating beautiful and interesting pieces of art. As "an elegant metaphor for deliberate artistry in life," according to its creators, Zentangle focuses on the process of art creation rather than the end result. Its approach involves drawing each stroke deliberately and consciously, without worrying about or concentrating on the final outcome. The journey is in the process, and the beauty of Zentangle is that there is no right way or wrong way. If you can put pencil or pen to paper, you can tangle. Engaging and approachable enough for someone who has never picked up an art tool, Zentangle is still inspiring enough for an advanced artist to embrace and enjoy. To learn more about the history of Zentangle or to learn how to become a Certified Zentangle Teacher (CZT), visit www.zentangle.com.

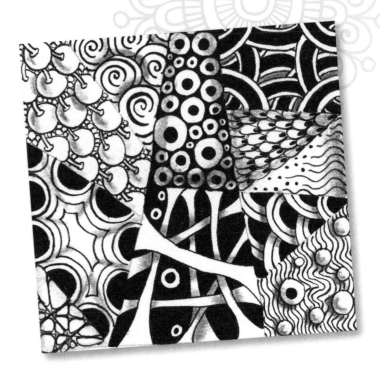

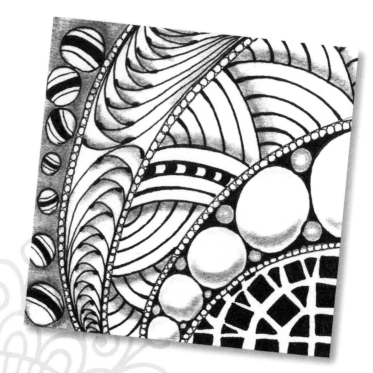

HOW TO USE THIS BOOK

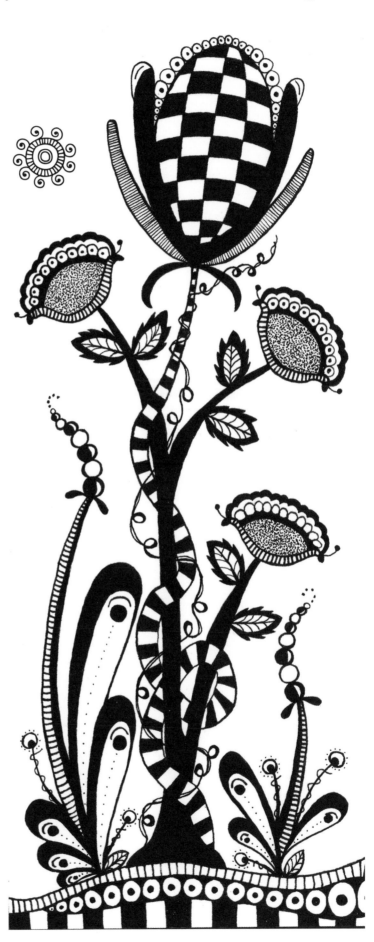

Welcome to The Art of Zentangle®! Whether you're a veteran tangler or are discovering Zentangle for the first time, you're sure to find fun and inspiration in the pages of this engaging and interactive book. From learning to create basic tangles and unique patterns to seeing the world through a tangler's eyes, innovation and inspiration abound in this guided journey thanks to the insights and creative expressions of four talented Certified Zentangle Teachers.

After learning about a few basic tools and materials, you'll be invited to explore the unique and interesting world of Zentangle through a variety of inspiring creativity prompts, projects, and practice exercises. Learn to create tangles following easy step-by-step lessons. Discover how easy it is to "see" strings and patterns everywhere you go (whether shopping for groceries or walking through a botanical garden). And indulge your whimsical side by learning to create Zentangle Inspired Art, tangled mandalas, funky wall art, and more. With tangling tips and practice pages that invite you to tangle to your heart's content, you'll be hooked on this fun and rewarding art form in no time! Turn the page to get started!

Happy tangling!

TOOLS & MATERIALS

All you really need to tangle is paper, a pen, and a pencil; however, there are a few optional materials you may want to have handy as you begin your tangling adventure.

Sketchpads and Drawing Paper – Sketchpads come in many sizes and are great for tangling on the go. There are a variety of quality drawing papers to choose from. Visit your local art supply store to see which you prefer.

Smooth and Vellum Bristol Board – These Bristol Boards are useful for creating Zentangle® Inspired Art (ZIA). Experiment with both to see which works best for you.

Hot-pressed Watercolor Paper – This paper's untextured surface lends itself to illustration and small details.

Pencils – In Zentangle, pencils are used to draw strings, create borders, and add shading. Pencils are designated by hardness and softness. H pencils are hard and make lighter marks; B pencils are soft and make darker marks. Pencils range from very soft (9B) to very hard (9H). You can also use standard No. 2 and No. 4 pencils.

Blending Stumps – Blending stumps allow you to blend or soften lines and areas of your tangles.

Sharpener – You can achieve various effects depending on how sharp or dull your pencil is, but generally you'll want to keep your pencil relatively well sharpened.

Erasers – One cardinal "rule" of tangling is that there are no mistakes, making erasers unnecessary; however, when creating some types of Zentangle Inspired Art, you may want to remove old sketch lines as a means of cleaning up your final artwork. Kneaded erasers are moldable and can be shaped into a fine point or used over broad surfaces. They leave no dust and are great for lifting out highlights. Vinyl erasers are great for removing graphite without chewing up the paper.

Archival Ink Pens – Tanglers typically use archival ink pens to render their finished artwork. It's helpful to have a selection of pens in every point size. Take time to familiarize yourself with these pens before getting started. Pens are typically numbered as follows:

005 pen	=	0.20 mm point
01 pen	=	0.25 mm point
02 pen	=	0.30 mm point
03 pen	=	0.35 mm point
05 pen	=	0.45 mm point
08 pen	=	0.50 mm point

Colored Pencils – Colored pencils are a convenient and easy method for applying color. Professional-grade colored pencils have a waxy, soft lead that is excellent for shading and building up layers of color gradually. Watercolor pencils are another excellent choice for adding color to your Zentangle Inspired Art.

Gel Pens – Gel pens consist of pigment suspended in a water-based gel. They deliver thick, opaque color and work easily on dark or previously colored surfaces. They are perfect for finishing details in your illustrations or for adding details and accents.

Art Markers – Professional art markers create bold, vibrant bands of color. They are great for laying down large areas of even color, as well as for shading.

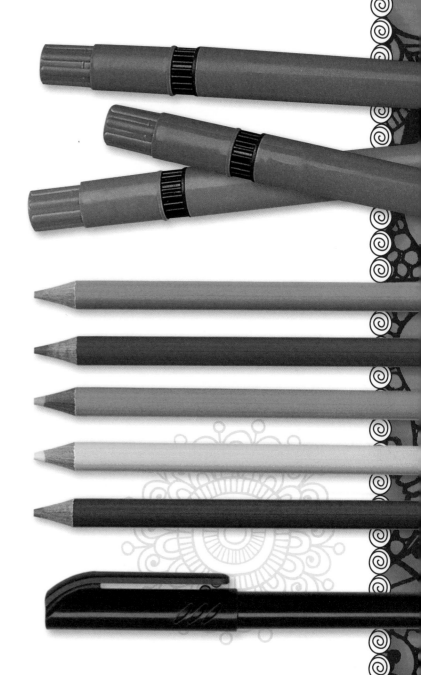

USING A LIGHT BOX

As its name suggests, a light box is a compact box with a transparent top and a light inside. The light illuminates papers placed on top, allowing dark lines to show through for easy tracing. Simply tape your drawing on the surface of the light box. Place a clean sheet of paper over your original sketch and turn the box on. The light illuminates the drawing underneath and will help you accurately trace the lines onto the new sheet of paper. Using a light box may come in handy when creating Zentangle Inspired Art.

GETTING STARTED

Just for fun, warm up your hand by drawing several random lines, scribbles, and squiggles.

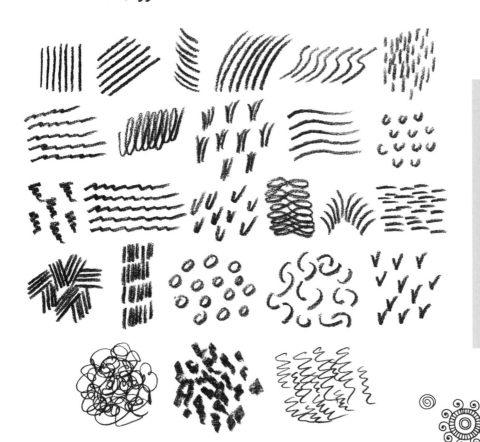

Known as "stippling," applying small dense dots is commonly used when embellishing tangles. Make the points different sizes to create various effects.

ZENTANGLE® TERMS

Border – An outline along the outer edges of the tile, enclosing the tangle inside the frame.

Certified Zentangle® Teacher (CZT) – An individual who has completed the CZT seminar taught by Zentangle® founders, Rick Roberts and Maria Thomas, is certified to teach the Zentangle® method.

Mosaic – The joining of two or more Zentangle® tiles to create a larger piece of artwork.

String – A random pencil line that serves as the guide upon which to tangle.

Tangle – The word "tangle" functions as both a verb and a noun. As a verb, "tangle" relates to the act of creating a work of Zentangle® art (e.g., "I am going to tangle today"). As a noun, "tangle" refers to the pattern created following the Zentangle® method.

Tile – A 3½- x 3½-inch quality archival paper upon which one tangles. Tiles can then be arranged into larger mosaics.

ENHANCEMENTS

An enhancement is an embellishment that you add to your tangle to give it character. Also known as tangle enhancements, they can be used alone or combined with other tangles for interesting results. The most common enhancements are aura, perfs, dewdrop, shading, rounding, and sparkle. Use the open spaces to practice them or to draw what inspires you.

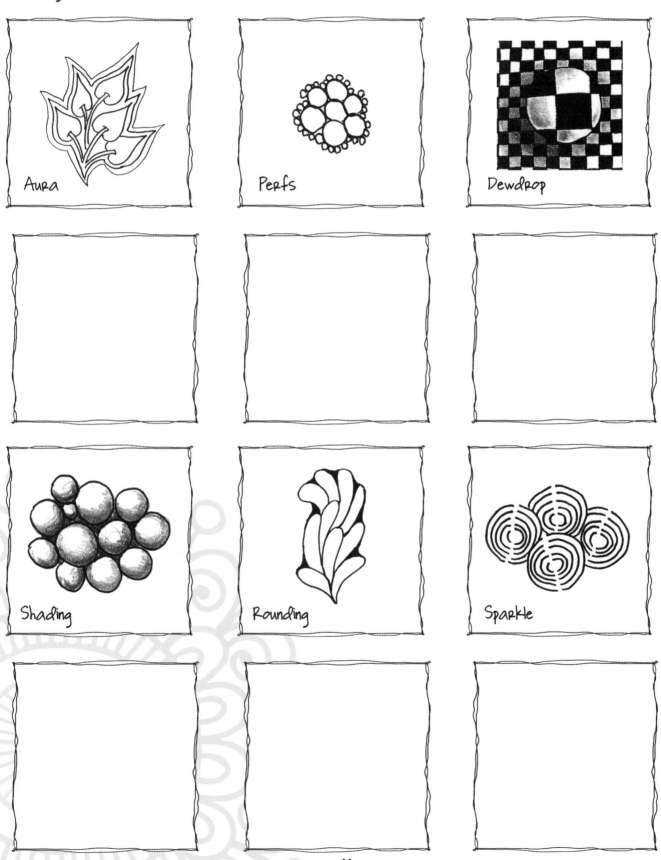

Aura

Perfs

Dewdrop

Shading

Rounding

Sparkle

PATTERNS & BORDERS

In this book, you will discover how to create patterns following basic steps. Patterns can then be joined to form borders. The next few pages show several examples of completed patterns and borders. Use them as inspiration to draw whatever moves you in the open spaces provided.

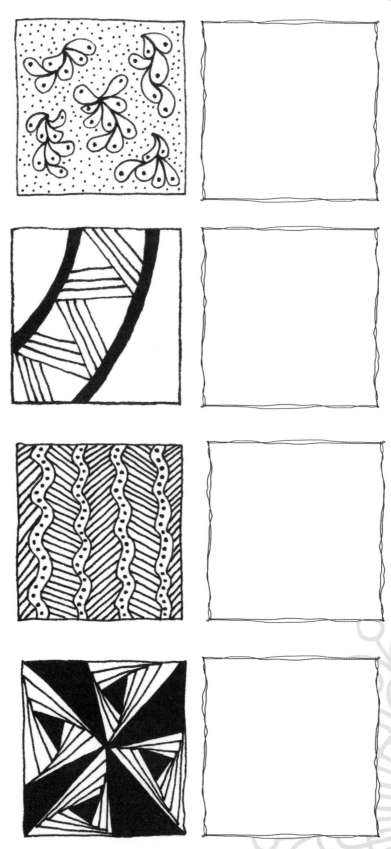

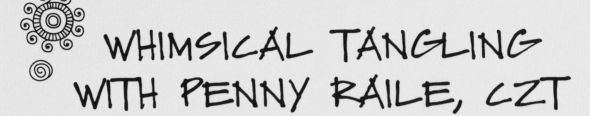

WHIMSICAL TANGLING WITH PENNY RAILE, CZT

More than any other art form, drawing quiets my mind and allows my thoughts to gather peacefully in one spot. In this place of calm, my inner child plays without fear; the adult is not allowed in. As my pen or pencil moves around the paper, ideas pop into my head and an imaginary world emerges full of silliness and folly. I have the complete freedom to explore and make things as I see them.

Inspiration comes from everywhere: Crumpled tin foil on a sidewalk looks like a circus elephant; a pattern on a coffee shop wall becomes the perfect background for a tangle; the woman sneezing next to me on an airplane transforms into a caricature. My eyes constantly wander, which sets my mind wondering all sorts of things like, "What magical creature lives inside that abandoned cardboard box?" "What if parking meters could talk with a British accent?" and "What would a six-legged llama look like?" The only thing I can't imagine is life without the joy of art.

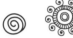 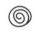 TIPS OF THE TRADE

• **Carry a sketchbook…Everywhere!** When you see a pattern that catches your eye, sketch it. I call my sketchbook the "Idea Catcher." It's full of patterns I've found and sketched—even in public restrooms and at traffic lights (red only, of course!)

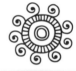

• **Find time to tangle.** Think you don't have time to tangle? Not true. Every Tuesday morning, I attend an office meeting for about two hours. By the end of the meeting, my handouts have tangled borders and patterns drawn all over them. If someone accuses you of not paying attention, remind the individual that it's been scientifically proven that random drawing helps with concentration.

• **Sign, date, authenticate.** Don't just sign and date your artwork. Include where you did the drawing! When I finish a tangle, I write on the back where I drew it. For example: *Frontier Airlines, flight 407, seat 4A* or *church, back pew.* (Remember: Drawing helps you listen better!)

• **Discover your personal slice of heaven.** To me, heaven is spending a rainy day on my couch next to my sleeping cat, with paper, pen, and a cup of coffee in hand. What's your idea of heaven?

CREATURES & SILLIES

Creatures are everywhere! The next time you go for a walk, take photos of interesting cracks on the sidewalk. Print them out and turn them around and upside down until you catch a glimpse of something, be it bird or beast. Trace the outline of your creature and fill it in with tangles; then embellish it as much or as little as you please to give your creature character.

Start with a photo. What do you see?

Use a little imagination!

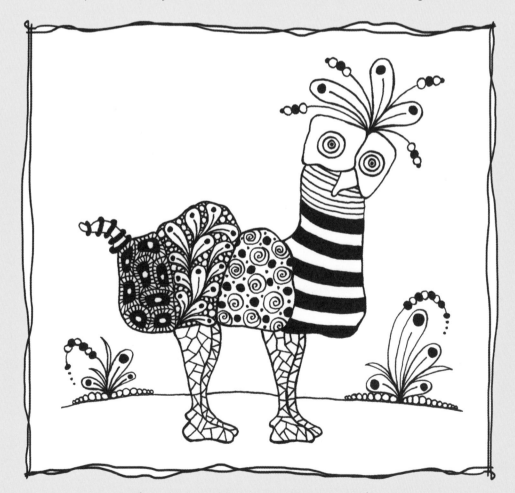

Ready to give it a try? Turn to page 20 to get started!

After you've snapped your photos, print your favorite one and attach it below. Then tangle your creature in the space provided.

Place Photo Here

Still need a little help getting silly? Select one or more characteristics from each of the tangled Sillies below. Then combine them to create a fourth tangled Silly in the space provided—or use these critters as inspiration for tangling your own Silly Creature!

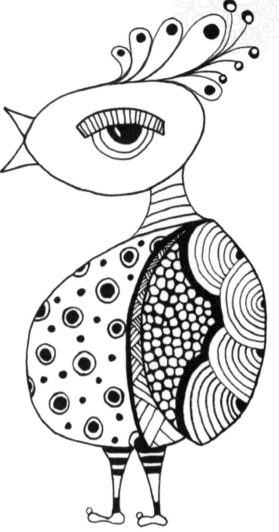

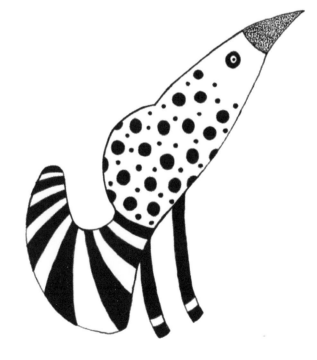

FLUX

When Rick Roberts demonstrated how to draw the Flux pattern at the second CZT workshop I attended, I fell in love with it instantly. The pattern lends itself to so many uses. Sometimes I use it as the main focus of a piece. Other times, I sneak a bit of it in just where I need fill. Use the opposite page to practice drawing Flux.

Step 1 Draw a single petal starting in the lower left corner of your tile or paper.

Step 2 Add more petals of varying sizes, alternating directions as you move toward the upper right corner of the tile.

Step 3 Continue the process from steps 1 and 2 until you have filled in the space with petals.

Step 4 Fill in the empty space surrounding the petals with circles of varying sizes.

Step 5 Now add a curved line in the middle of each petal, topping it off with a large solid dot.

Step 6 Fill in any areas, as needed.

PRACTICE HERE!

FLUX VARIATIONS

Try your hand at copying these Flux variations on the opposite page, or create some Flux variations of your own.

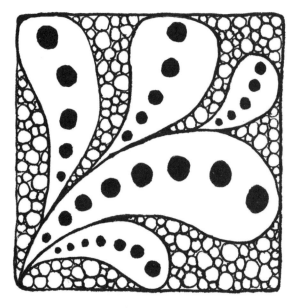

In this easy variation, simply replace the lines in the middle of the petals with large and small solid dots.

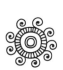

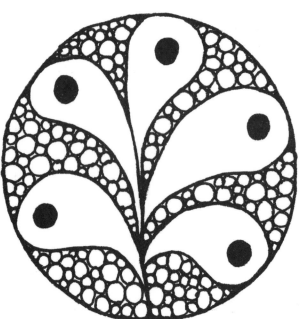

Instead of a square outline, start your tangle with a circle. Follow the same basic steps to create this variation.

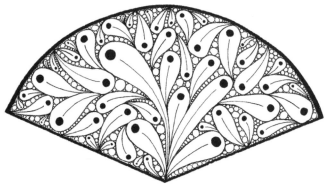

Feeling really creative? Try a funky-shaped border, like this fan. Draw the Flux petals in a variety of sizes and different directions.

PRACTICE HERE!

HOLLIBAUGH

Molly Hollibaugh, daughter of Maria Thomas, created the Hollibaugh pattern. It's great for filler and it looks especially fantastic when it's drawn small. Use the opposite page to practice drawing this basic tangle.

Step 1 Draw two parallel lines across the lower left corner inside your tile. Then draw a second pair of parallel lines at a different angle that intersect "behind" the first set of lines.

Step 2 Add yet another set of parallel lines at a different angle, again intersecting "behind" the first two sets.

Step 3 Continue to add sets of parallel lines at various angles until the tile is filled.

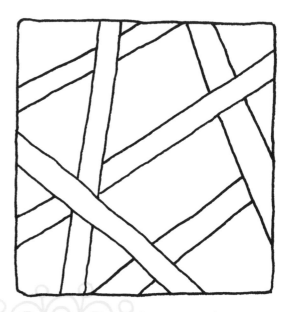

Step 4 Step back and admire your tangle!

PRACTICE
HERE!

HOLLIBAUGH VARIATIONS

The clean lines of the Hollibaugh tangle make creating variations a breeze. Use the opposite page to practice drawing the designs shown below, or create your own.

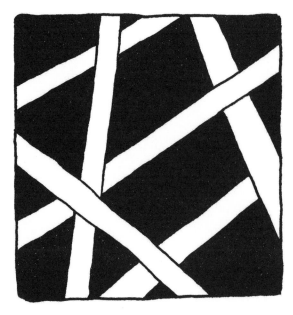

For a dramatic effect, completely fill in the negative space around your pairs of parallel lines.

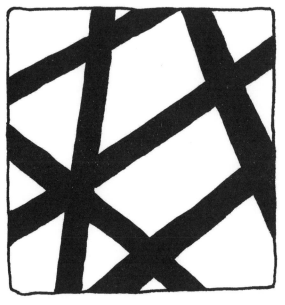

Alternatively, fill in each set of parallel lines.

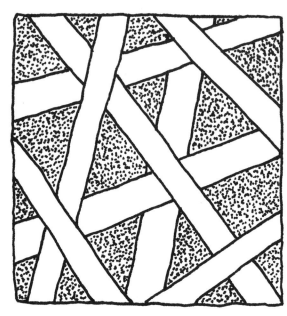

For a texturized effect, try stippling inside the negative space around your parallel lines.

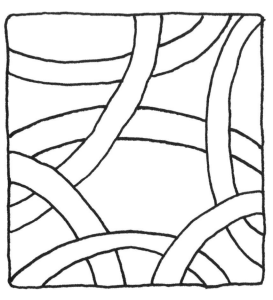

For a softer effect, try drawing your parallel lines as wide arcs instead of straight lines.

PRACTICE
HERE!

ROXI

I created Roxi when I needed a border for a drawing. It is simple and quick. When I am in meetings, I find myself adding this pattern to my notes. Use the opposite page to practice drawing this tangle.

Step 1 Draw a curved line starting at the lower left edge of your tile. Top it with an almond shape.

Step 2 Repeat step 1, building the design on top of the first.

Step 3 Continue this pattern, curving your lines to create a snakelike pattern up the middle of the tile.

Step 4 Fill in the remaining space; then step back and admire your work.

PRACTICE
HERE!

ROXI VARIATIONS

Roxi is fun to experiment with because there are endless variations you can create. Use the opposite page to practice the variations shown or to work out your own ideas.

A circular Roxi tangle is useful for filling in larger shapes and negative space in your artwork.

For a 3D effect, double up each single line to create a "stem" running through each almond shape. Add a bit of shading at the base where the stem meets the "petal" to give the illusion of dimension.

Roxi is a versatile tangle that you can play with to create different designs. In this case, I added little embellishments to create a "hanging beads" effect.

PRACTICE HERE!

FISH AQUARIUM

One of the most rewarding things about tangling is the fun that comes with letting your imagination run free. Whether you prefer to tangle space aliens or ocean creatures, there is no limit to what you can create. For this project, take your tangling skills to new heights—or depths—by using a variety of tangles, enhancements, loops, lines, and borders to create an exotic aquarium filled with zany fish and wild sealife.

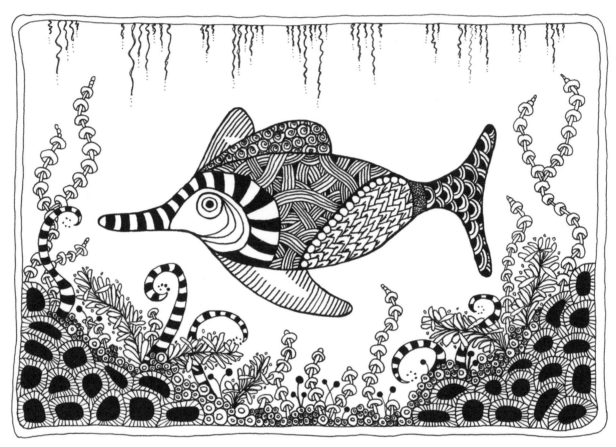

Look at all of the fun things you can fill your aquarium with. Use the opposite page to practice tangling the tank filler shown below or to create designs of your own.

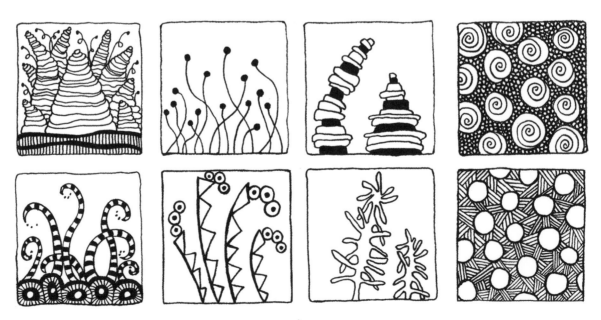

Fill in the fish templates below with tangles. Experiment with line weights and designs. Don't be afraid to be as creative as your imagination will let you!

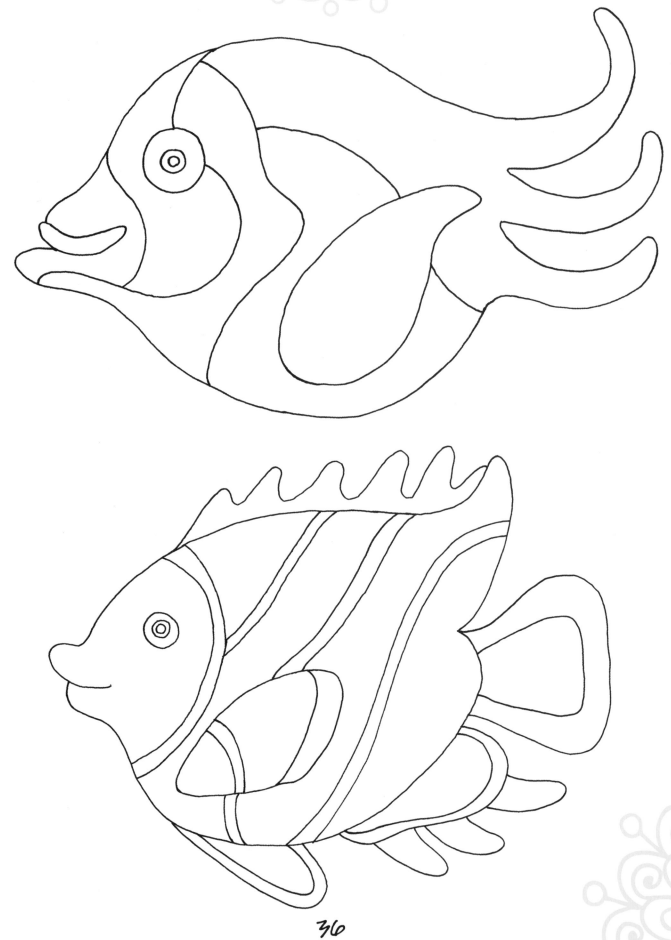

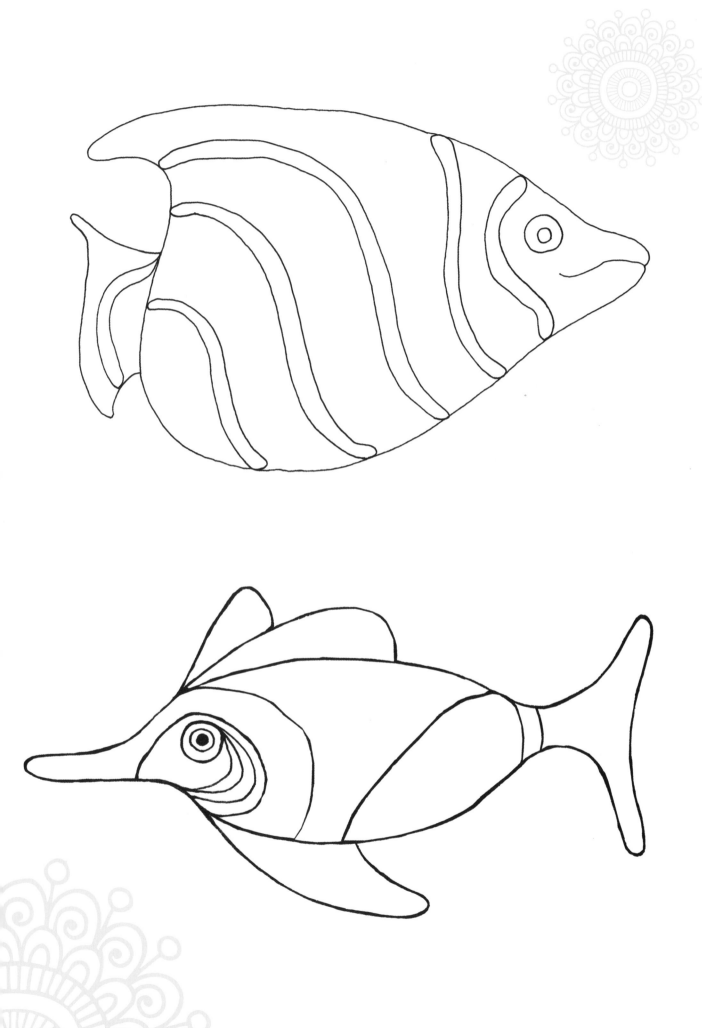

37

Now put all of the elements together to create an exotic tangled underwater world!

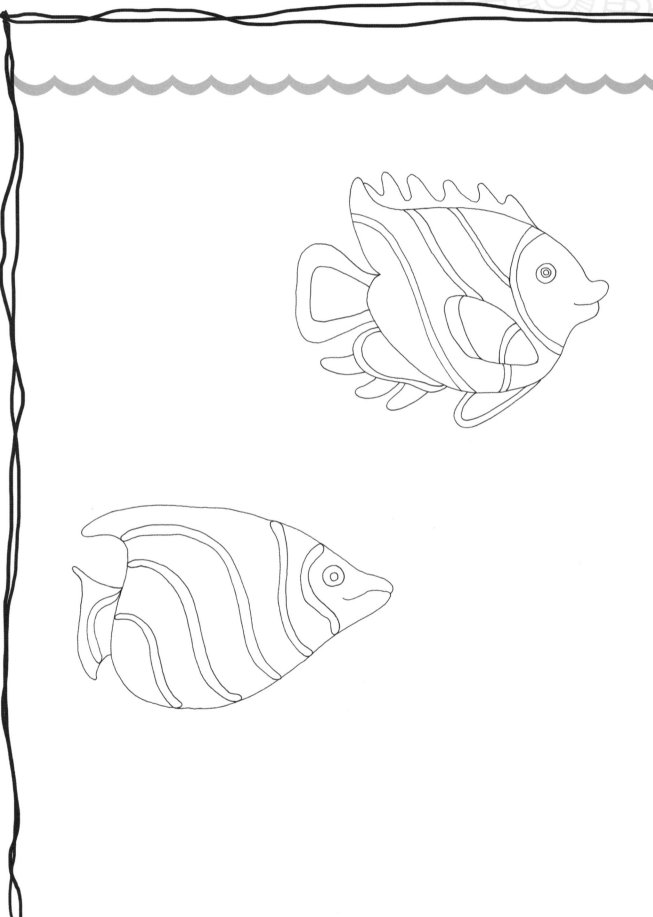

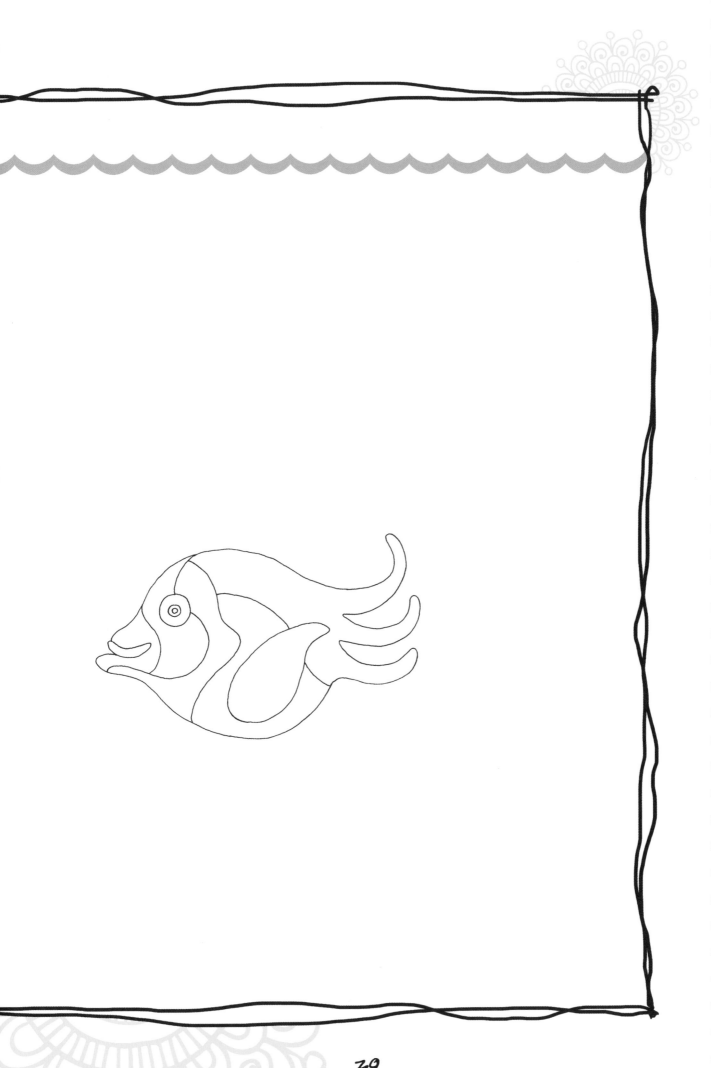

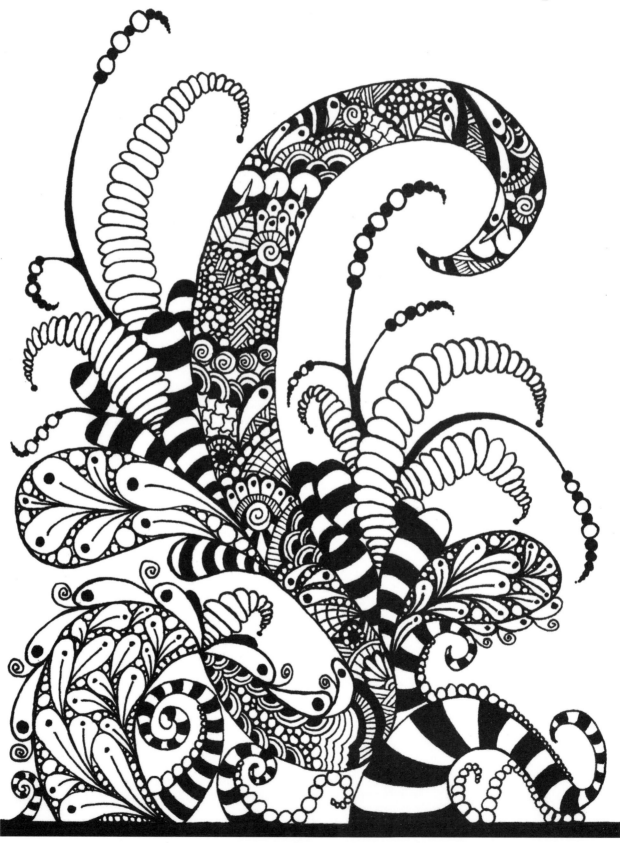

PROJECT #2

FANTASY GARDEN

Zentangle® art is perfect for creating a whimsical tangly garden. Swirls, circles, squiggles, and loops make for some fun flora and fauna! Fantasy gardens can grow in several directions and feature any and all of the tangles you like.

Use the open spaces below to practice tangling these fun garden patterns.

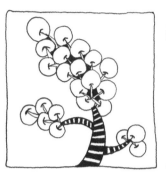

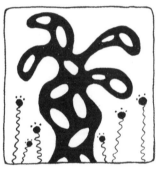

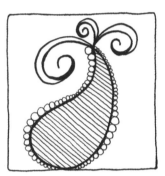

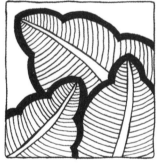

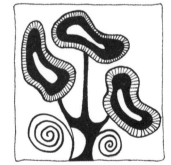

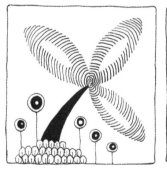

Flowers are essential to a tangled fantasy garden. Practice the flowers shown below in the spaces provided. Then create a couple of your own!

Don't forget to add a variety of birds, bees, and butterflies to your fantasy garden. Use the template below to practice tangling this sweet hummingbird.

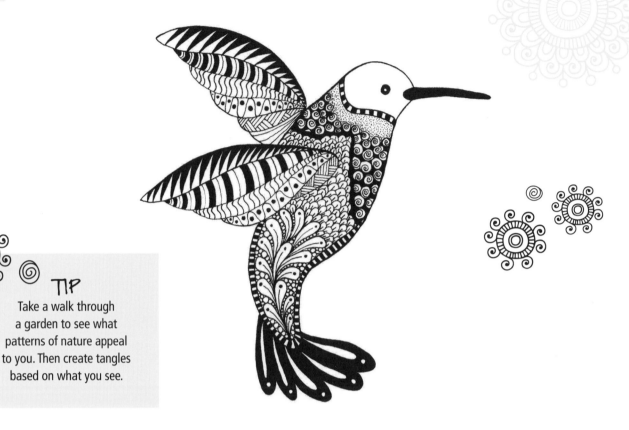

TIP
Take a walk through a garden to see what patterns of nature appeal to you. Then create tangles based on what you see.

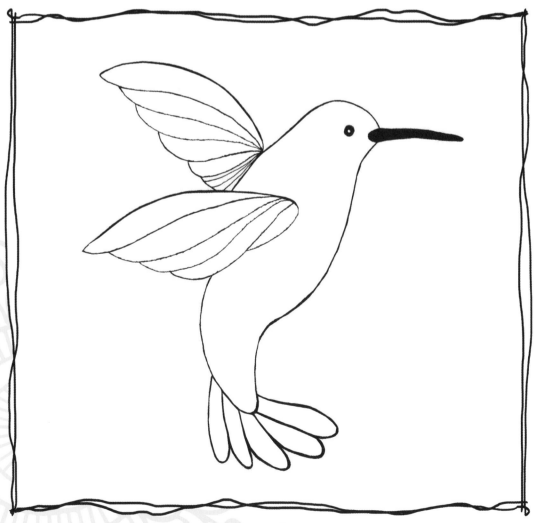

Now it's time to create your own whimsical fantasy garden! Use the artwork below as inspiration to get started. Then tangle away!

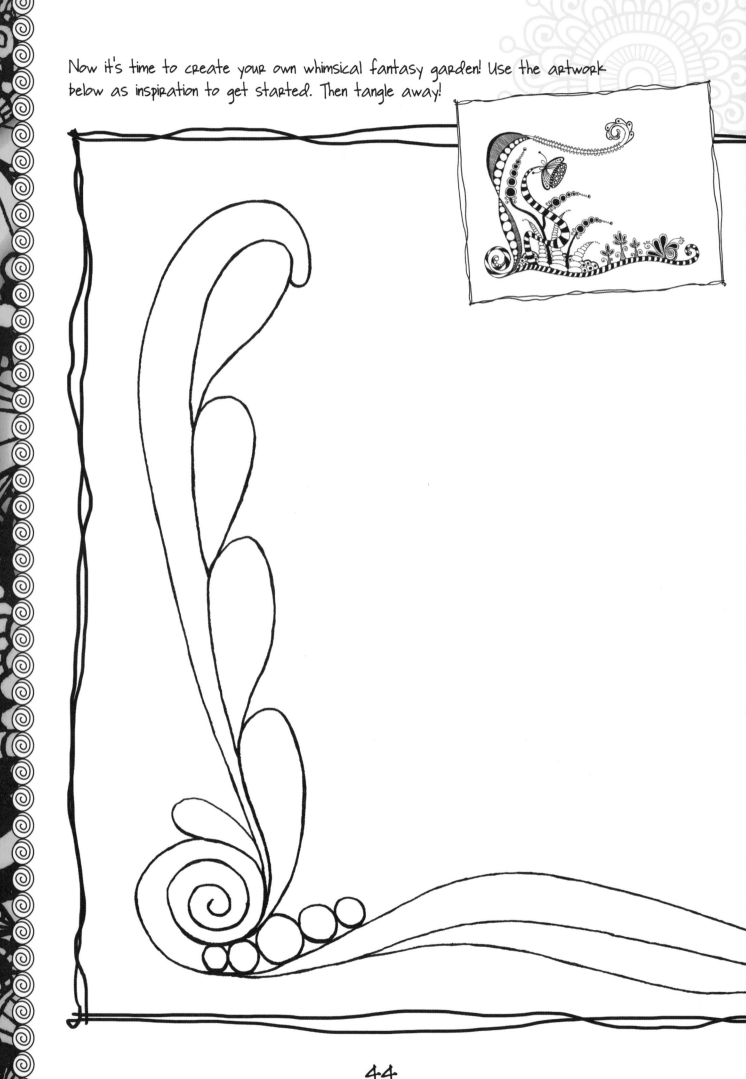

TANGLY TOADSTOOLS

What's more fun than a tangly fantasy garden? Tangly toadstools, of course!
Zentangle® naturally lends itself to the whimsical nature of these tangles.
Using the toadstools below as inspiration, fill in the blank toadstools on the
opposite page with the tangles of your choice.

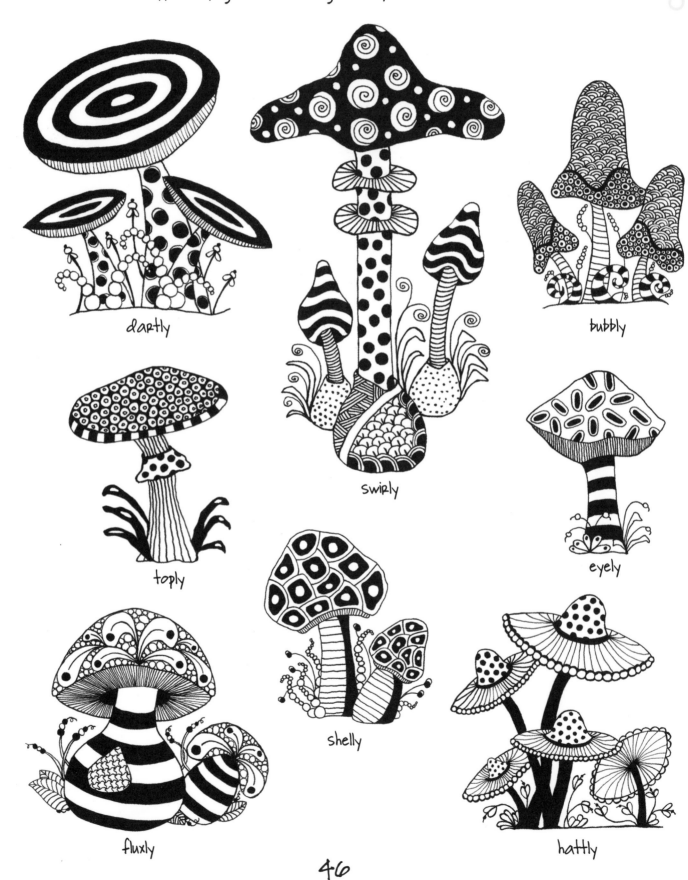

dartly

bubbly

swirly

toply

eyely

shelly

fluxly

hattly

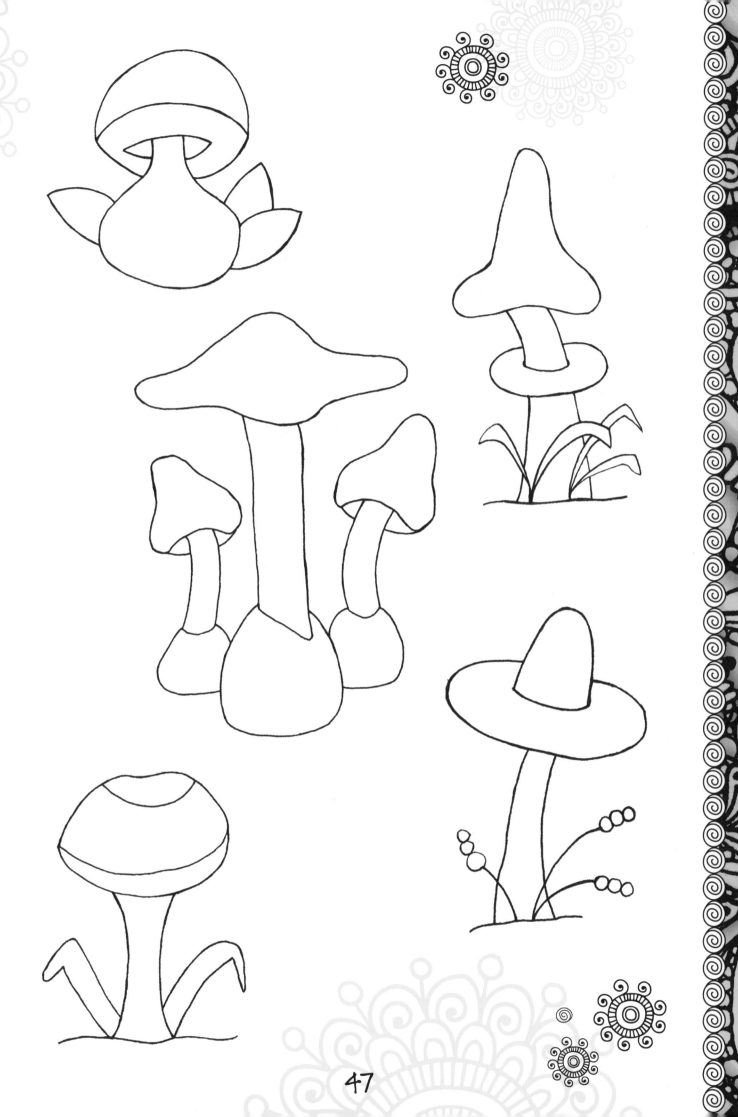

TANGLED MOTIFS

A wonderful source of inspiration can be found in your favorite motifs, such as this Japanese bonsai tree. Fill in the treetops and branches with tangles that inspire you. Then look to nature or books to come up with motifs of your own.

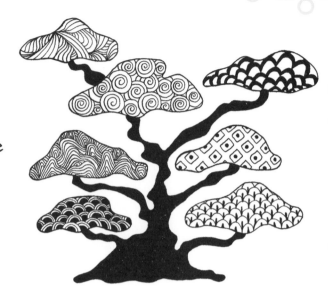

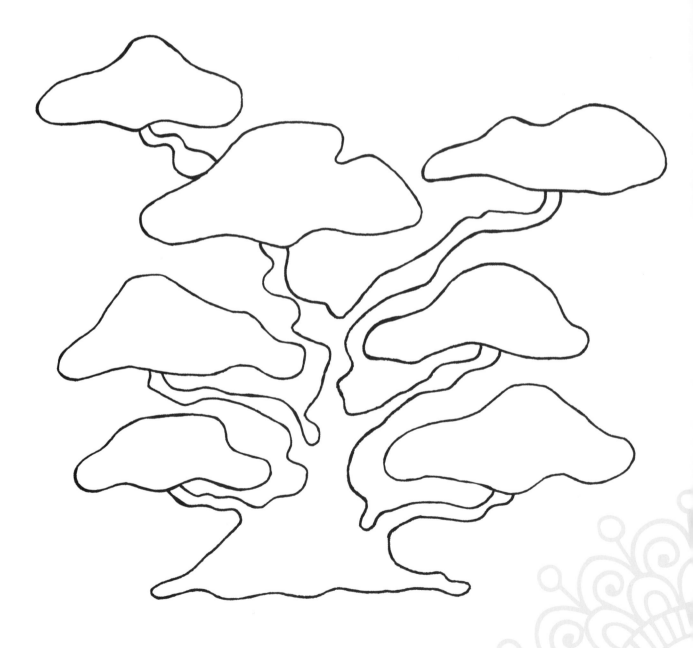

CHANNELING PICASSO

On a piece of paper, draw a random free-form string. Next, fill in the sections with geometric shapes and Picasso-inspired designs. Add a face for a genuine piece of abstract tangled art!

Step 1

TIP

Feel free to get as creative as you like with your abstract face. Why not place the mouth above the eyes and the nose below the chin?

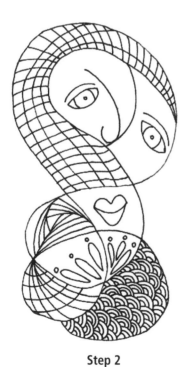

Step 2

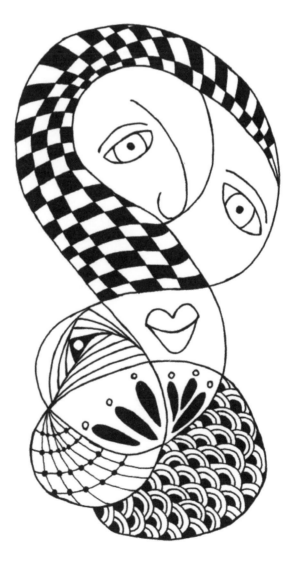

Step 3

SILHOUETTE TANGLES

As an art form, Zentangle® can be as simple or as complex as you desire. I love to create "extreme" tangles, such as the dense, intense tangle shown below. Extreme tangles are great for creating silhouettes, as well. Notice how the bunny, rooster, and cat silhouettes on the opposite page all "pop" against the extreme tangled pattern.

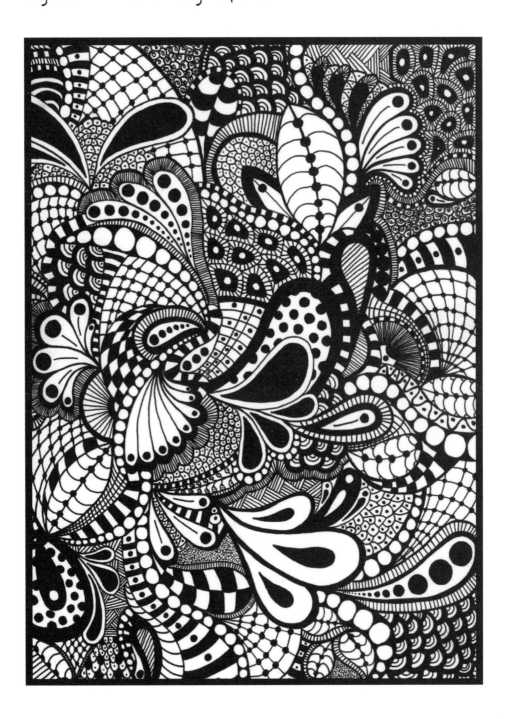

TIP
Extreme tangles provide a great opportunity to experiment with line shapes and widths. Thick lines and dark shading are key characteristics of these tangle patterns.

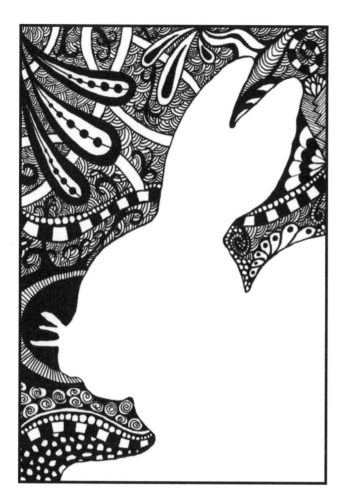

To create an extreme tangle silhouette, simply sketch the outline of the animal or object on your tile or paper. Then fill in the space around the silhouette with dark, dramatic tangles of your choice.

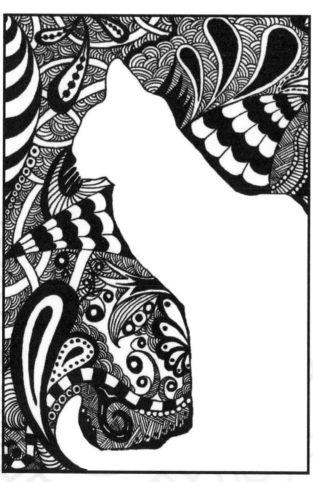

Ready to practice some extreme silhouette tangling?
Turn to pages 52-53!

Use the templates below to practice creating extreme tangled silhouettes. When you are finished, turn to pages 54-55 to draw your own silhouette shapes to tangle around.

PRACTICE HERE!

PRACTICE
HERE!

ZENTANGLE® INSPIRED ART WITH NORMA J. BURNELL, CZT

From the moment I first discovered Zentangle®, I was hooked. Learning Zentangle has opened the door to many creative possibilities in my personal artwork, particularly in my fantasy art. Zentangle Inspired Art, or ZIA, is a method of combining Zentangle® with other forms of art. I often create ZIA by adding tangles to create unique fantasy drawings that I call Fairy-Tangles™. I also like to incorporate many of the patterns I see in nature into my Zentangle and ZIA pieces. The magic of nature inspires me, from the little hummingbirds that visit my summer garden to the great horned owls heard throughout the winter nights. Nature's treasures, such as seed pods, grasses, flowers, leaves, and even stones on a beach, provide patterns that can serve as inspiration for a tangle. Next time you go outside, look around to really "see" what inspires you. My hunch is that whatever it is will make a great tangle. Zentangle® is a process; there is no right or wrong way. It simply involves putting pen to paper one stroke at a time. So, relax, breathe, and enjoy the process!

TIPS OF THE TRADE

- **Turn your paper.** If a stroke feels awkward, try turning your paper so the stroke flows smoothly from your hand.

- **Draw outside the lines.** Don't be afraid to let things go in your drawing. The string is there only as a guide, but it's OK to push beyond it.

- **For the best shading results,** use softer lead pencils: 3B, 4B, and 5B pencils produce rich, dark tones.

- **Tangle away!** Remember, you can tangle on just about anything. I have a pair of white shoes that are no longer white—they've been tangled!

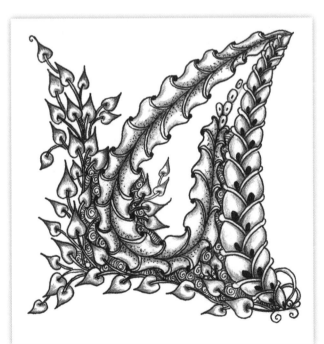

FINDING INSPIRATION...

...IN THE KITCHEN

Take a trip through your kitchen and look for an object you'd like to tangle. It can be anything: a teapot, a coffee mug, a fruit basket. Using the sample below as a guide, draw an outline of your object. Add a string inside the outline. Then fill in the design with the tangles of your choice.

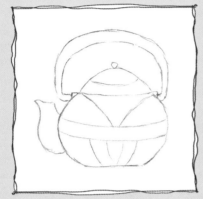

Start with a loose sketch.

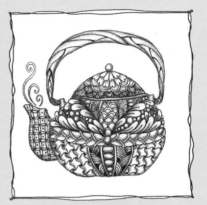

Get as creative as you like!

...IN NATURE

Take a leisurely stroll around your yard, garden, or local park. Notice how leaves, seed pods, and flowers are all made of repetitive patterns. How many different patterns you can identify? Using the samples below as a guide, try creating your own nature-inspired patterns.

Inspired by seed pods cast from a butterfly weed.

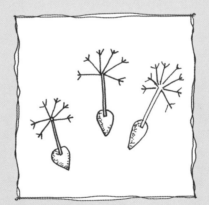

Inspired by carrot tops.

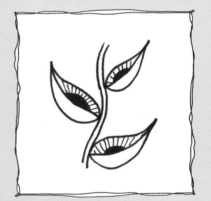

Inspired by leaves and vines.

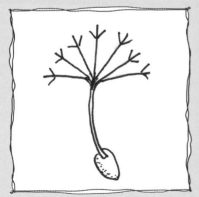

Inspired by dandelion puffs.

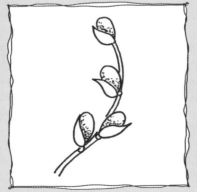

Inspired by pussy willows.

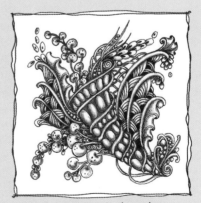

Several nature-inspired tangles combined into one piece of art.

POKELEAF

Pokeleaf is a variant of Pokeroot. Both are official Zentangle® patterns designed by Zentangle co-founder, Maria Thomas. Pokeleaf is a great tangle to use for achieving an organic feel to your art. It can also be used to fill areas or to enhance other tangles. Once you've mastered this basic tangle, try adding enhancements and backgrounds to spice it up. You might also consider having a Pokeleaf "grow" out of other tangles. Use the opposite page to practice drawing Pokeleaf.

Step 1 Using your pen, draw a double curved line to create a stem and an upside-down "smile" to show where the stem and leaf meet. Starting on one side of the stem, draw a narrow upside-down heart shape that ends on the other side of the stem.

Step 2 Follow step 1 to create two more leaf stems.

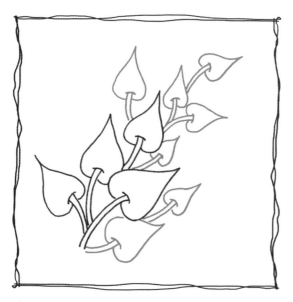

Step 3 Continue to add more stems and leaves, going back and overlapping a few to add depth and dimension.

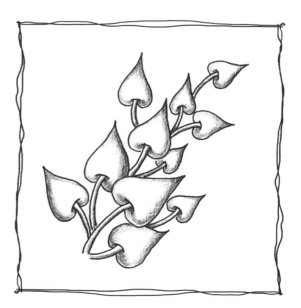

Step 4 Using the side of a No. 4 pencil, shade around the interior edges of the leaves, as well as down the length of the stems. Use your finger or a cotton swab to blend the shading, if necessary.

PRACTICE HERE!

POKELEAF VARIATIONS

With a few simple changes, you can create endless Pokeleaf variations for completely new tangles. Try experimenting with a variety of shapes. Some may not always work, but you never know what you'll discover by simply trying. Use the practice page at right to try your hand at these Pokeleaf variations.

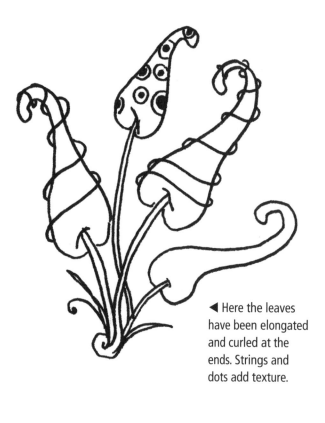

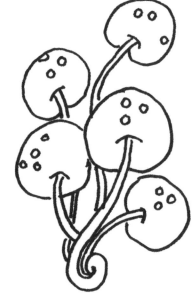

◀ By making the leaves round, Pokeleaf becomes Pokeroot—the official tangle from which Pokeleaf derives.

◀ Here the leaves have been elongated and curled at the ends. Strings and dots add texture.

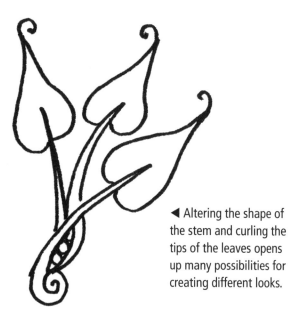

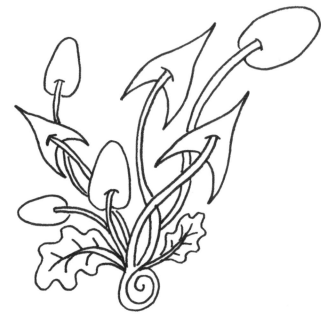

◀ Altering the shape of the stem and curling the tips of the leaves opens up many possibilities for creating different looks.

Varying the shapes of the leaves also adds fun and whimsy. In this variation, I've combined arrow and oval shapes with a few squiggly leaves.

PRACTICE HERE!

DRAGONAIR

I created Dragonair from a combination of the official tangles, Fescu and Cadent. It comes together quickly and easily with a few simple strokes, making it a true tangle pattern. Dragonair is adaptable and can be used in various ways to create different effects. Use the opposite page to practice drawing Dragonair.

Step 1 Draw a long backward S-shaped guideline. Starting at the bottom of the guideline, draw a backward C-shaped line with a shaded dot on the tip. Repeat this up the length of the guideline, gradually elongating the C-shaped curves. Add a tiny line and dot at the tip of the guideline.

Step 2 Working left to right, connect each shaded dot along the top of the Dragonair with small backward S-shaped lines.

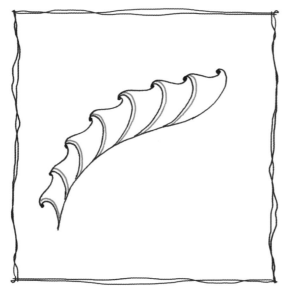

Step 3 Draw a thin parallel line to the immediate right of each vertical C-shaped curved line inside the Dragonair.

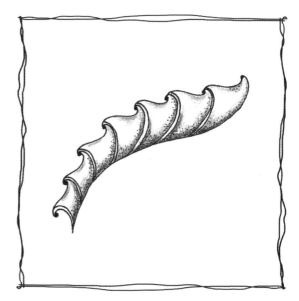

Step 4 Add stippling along the bottom and up the inside lines of Dragonair. With a No. 4 pencil, shade directly over the stippling. Use heavier pressure along the bottom and lighter shading along the top.

PRACTICE HERE!

DRAGONAIR VARIATIONS

Dragonair is a fun tangle to experiment with. Use the opposite page to practice these variations or to create your own.

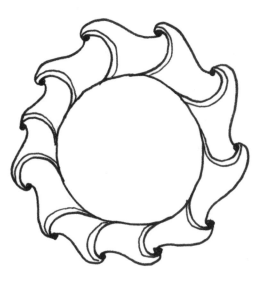

◄ Lightly draw a circle to serve as your guide; then "wrap" Dragonair around the circle. Experiment with wrapping Dragonair around other shapes, as well.

► You can also add a smaller Dragonair to the inside of your circle.

◄ Here I've added large circles, instead of dots, at the end of each curve. You may opt to add dots, fill the circles in completely, or add smaller circles or stippling inside.

◄ For a podlike effect, draw double-facing Dragonair tangles and connect them with curved lines.

◄ By varying the sizes of the curves and ridges, and by having other tangles "grow" out of Dragonair, I've created a very organic-looking tangle, don't you think?

PRACTICE
HERE!

CHAINLEA

Chainlea emerged while I was working on a ZIA Fairy-Tangle™ archer. I wanted to create something that would work as a strap for my fairy's quiver of arrows, so I came up with Chainlea. I've since found many other uses for Chainlea, and I often work this tangle into my other Fairy-Tangle™ pieces. It works well as a border or grouped together to fill a section. I called this tangle Chainlea because it reminds me of a chain and a leaf.

◄ Step 1 Lightly draw a banana-shaped guideline. Draw two parallel curved lines from the bottom middle of the guide to the right interior edge, keeping the lines close together. Then draw a second set of lines to the left edge of the guide.

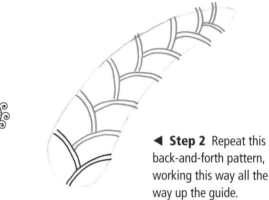

◄ Step 2 Repeat this back-and-forth pattern, working this way all the way up the guide.

◄ Step 4 Now close the sets of double lines by drawing C-shaped loops around them. Close the bottom double lines by adding a cute curlicue.

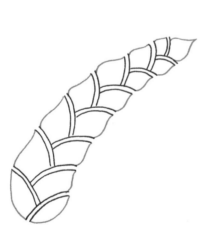

▲ Step 3 Use an eraser to remove your banana-shaped guideline. Working from the bottom up, draw slightly curved lines connecting the outside points of the interior parallel lines, making sure to leave the space between each pair open. At the top of the Chainlea, bring the two curved lines to a point.

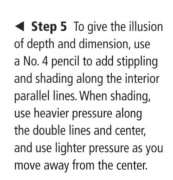

◄ Step 5 To give the illusion of depth and dimension, use a No. 4 pencil to add stippling and shading along the interior parallel lines. When shading, use heavier pressure along the double lines and center, and use lighter pressure as you move away from the center.

PRACTICE
HERE!

CHAINLEA VARIATIONS

With a bit of imagination, you can create an array of Chainlea variations. On the opposite page, try copying the variations shown below. Better yet, create your own!

◀ Here I closed each curved line in a sharp point. I also added another tangle "growing" out of the top—a common Zentangle® technique.

◀ In this variation, I exaggerated the curve of the connector line and added little seedlike shapes at the base of each chain section.

▲ For a fuller, rounder effect, I widened and exaggerated the curved connecting lines around the pattern. I also closed the double lines by drawing their loops downward for a slight 3D effect. For fun, I added a few random discs spitting out of the top.

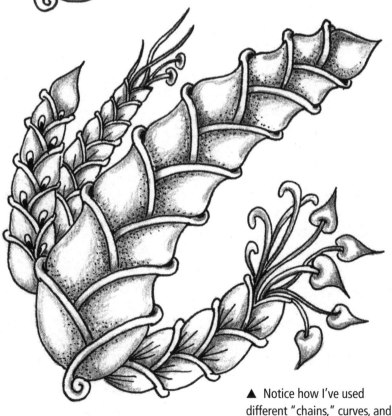

▲ Notice how I've used different "chains," curves, and embellishments to showcase how variations of Chainlea can be combined with each other and with other tangles.

TIP
Chainlea is especially fun to embellish. Add wild leaves growing out of the top, or draw a series of dots and circles spitting out from the top!

PRACTICE
HERE!

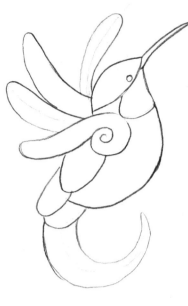

HUMMINGBIRD

PROJECT #5

Birds make perfect Zentangle® Inspired Art. I started this ZIA piece by first drawing the hummingbird's basic shapes, which provide the "string," or guidelines, for adding the tangles inside. Give it a try!

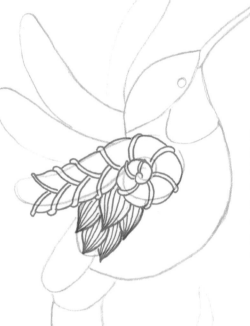

▲ **Step 1** Sketch the outline of the hummingbird.

Step 2 Starting from the center of the middle wing, draw a spiral loop. Draw evenly spaced parallel lines inside the loop guidelines, working your way around the circle. Next, use a 01 pen to trace around the spiral, beginning the formation of a Chainlea. Add featherlike tangles along the bottom of the wing.

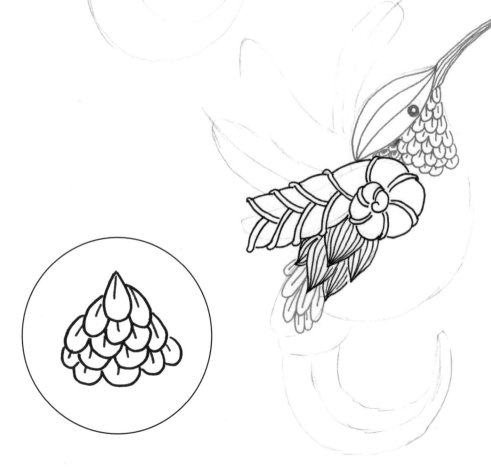

Step 3 Continuing with your pen, draw an almond-shaped tangle along the top of the head from the tip of the wing to the start of the beak. Add a small circle for the eye. Using a 005 pen, draw the outside of the beak, adding two parallel lines inside from base to point. Switch back to a 01 pen, and fill in the neck and a few body feathers with the official tangle, Tagh (see inset).

70

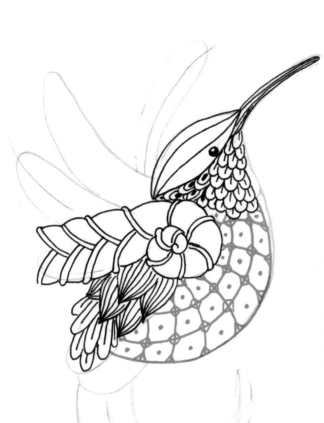

Step 4 Using your 01 pen, trace along the outside of the bird's chest. Then fill in the area with the official tangle, Florz, starting with vertical and horizontal lines that follow the contours of the shape. Draw a small diamond shape around the intersecting points, and add dots in the center of each open space to create the pattern (see inset).

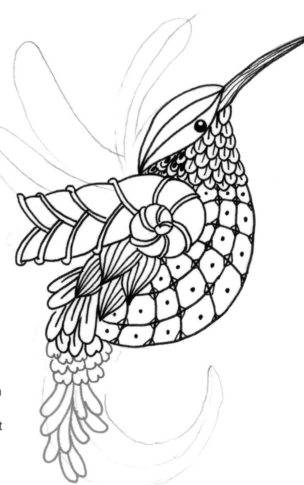

Step 5 Now draw a few upside-down hearts to fill in the rump area of the little hummingbird, followed by an elongated Flux tangle to start the tail (see inset).

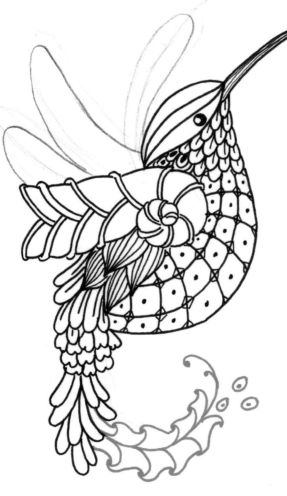

Step 6 For the rest of the tail, begin the Dragonair tangle, curving outward on both sides of the centerline. Add a few little embellishments off the tip of the tail.

Step 7 Starting at the base of the head, use your pen to draw another Chainlea over the guideline, creating the bird's other wing.

TIP
It's OK to draw outside the lines! It makes for a more natural flow between the tangles.

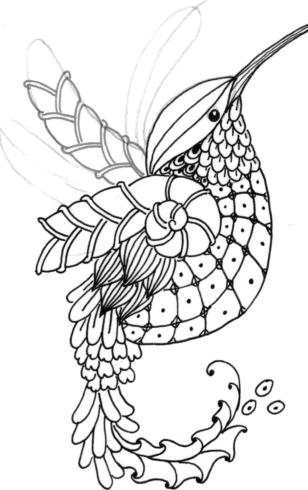

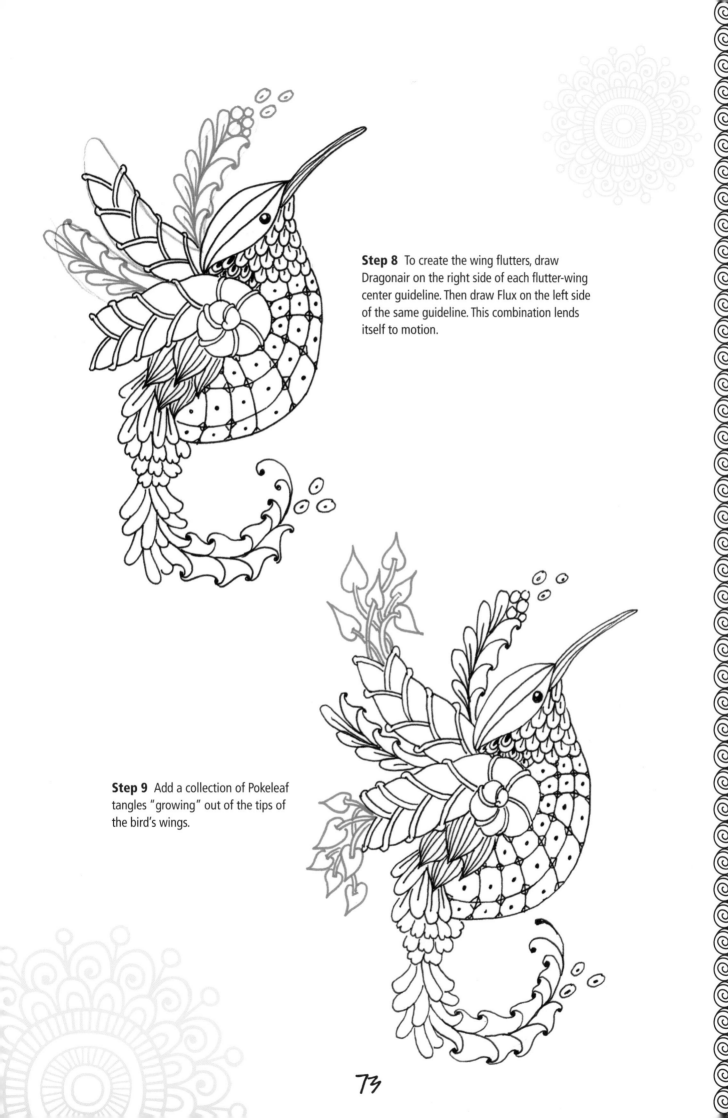

Step 8 To create the wing flutters, draw Dragonair on the right side of each flutter-wing center guideline. Then draw Flux on the left side of the same guideline. This combination lends itself to motion.

Step 9 Add a collection of Pokeleaf tangles "growing" out of the tips of the bird's wings.

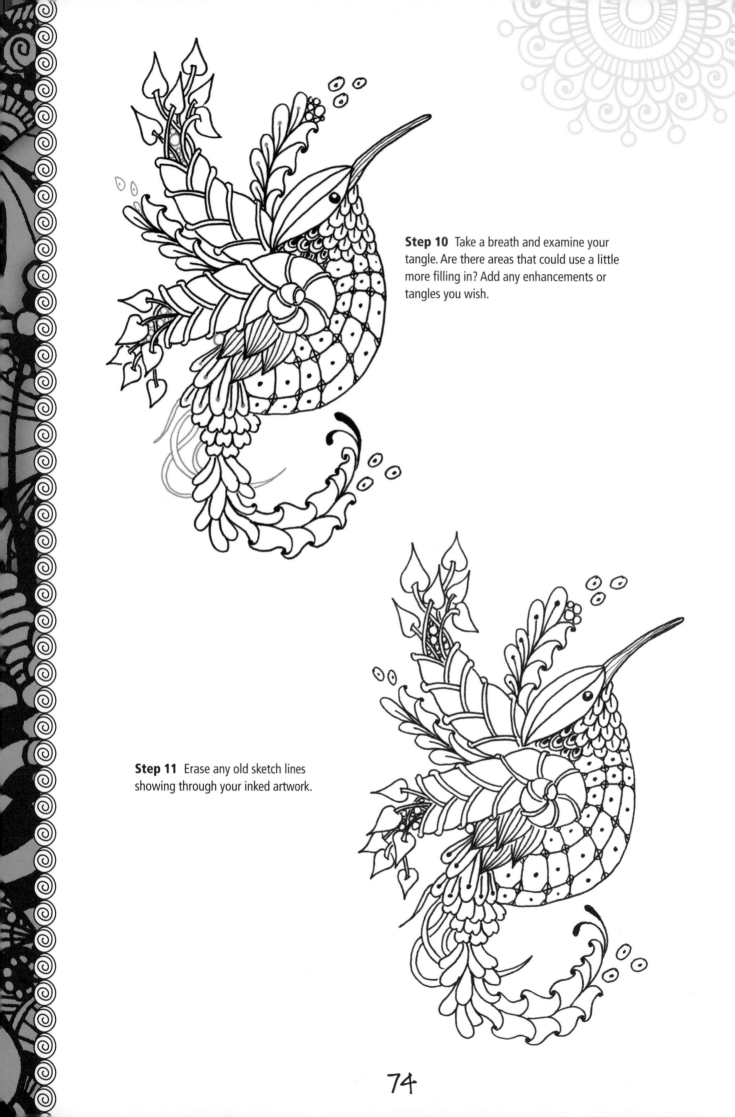

Step 10 Take a breath and examine your tangle. Are there areas that could use a little more filling in? Add any enhancements or tangles you wish.

Step 11 Erase any old sketch lines showing through your inked artwork.

74

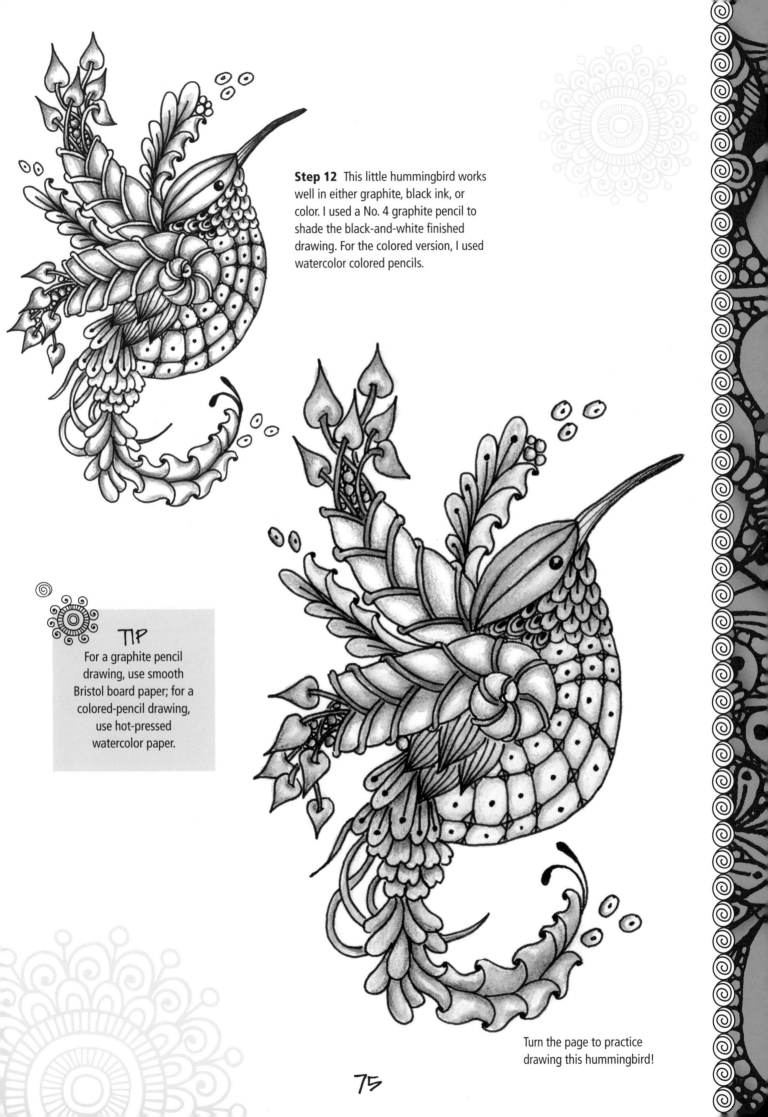

Step 12 This little hummingbird works well in either graphite, black ink, or color. I used a No. 4 graphite pencil to shade the black-and-white finished drawing. For the colored version, I used watercolor colored pencils.

TIP
For a graphite pencil drawing, use smooth Bristol board paper; for a colored-pencil drawing, use hot-pressed watercolor paper.

Turn the page to practice drawing this hummingbird!

PRACTICE HERE!

PRACTICE HERE!

FAIRY

I started creating tangled versions of my fantasy art shortly after discovering Zentangle®; the two seemed a perfect fit for each other. The tangles lend a touch of whimsy and magic to the characters' hair and wings. In this piece, I started with a pencil drawing of an otherworldly face and then tangled around it. Your face does not have to be realistic—it can be a simple line drawing or even caricaturelike.

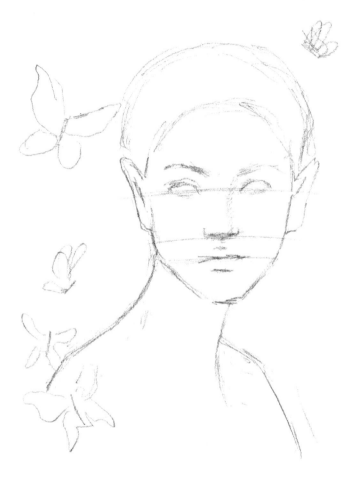

Step 1 With a No. 2 graphite pencil, lightly draw the outline of a face. Keep your pencil pressure light, so that your sketch lines can be easily erased when you are done adding tangles. Feel free to trace my fairy face sketch to get started.

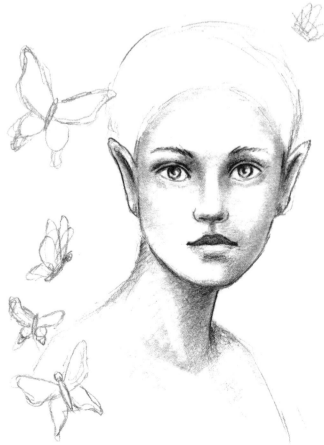

Step 2 Establish the facial features before starting to tangle.

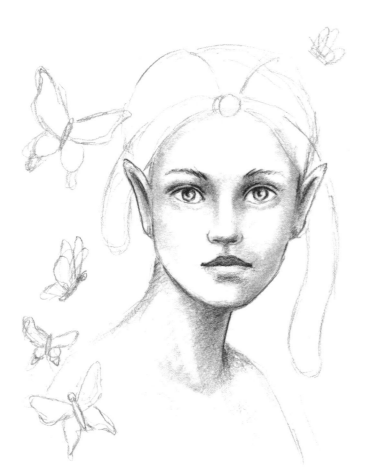

Step 3 Lightly sketch a small circle at the top of the forehead and a few lines to act as guides for the anchor tangles. Anchor tangles are a few well-placed tangles that give you a starting place for other tangles.

Step 4 Use your pen to trace over your pencil circle sketch. Add a few leaves around the circle to create a "crown" (see inset).

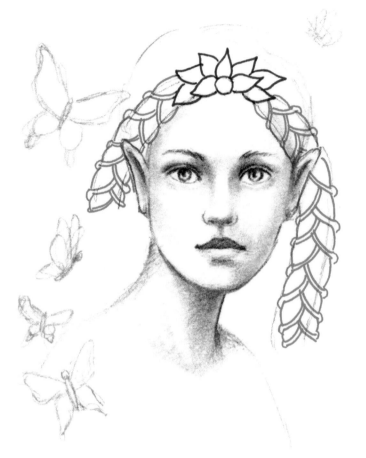

Step 5 Working from the top of the crown down, draw a Chainlea to establish several anchor tangles on either side of the face.

Step 6 Now trace over the butterfly sketch outlines. Add a new tangle from the top of the head down, working it behind the butterflies. I've used Punzle, one of my favorite tangles (see inset). You may want to practice this one before drawing it on your fairy.

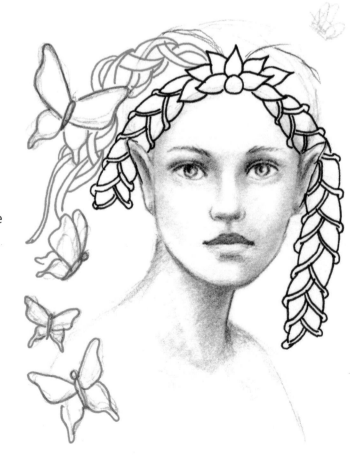

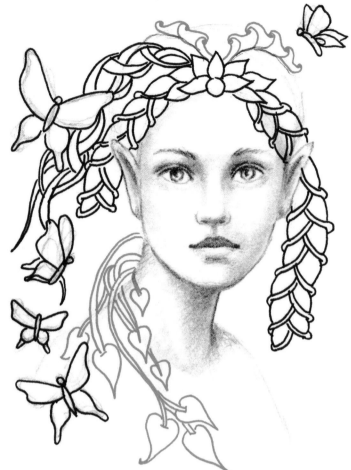

Step 7 Add Dragonair along the two curved guides coming out of the crown on the head. Then add a few Pokeleaf tangles coming out from behind the neck and spilling down over the fairy's shoulder.

Step 8 Draw a few circles around the crown, as well as a few curvy lines cascading down the other shoulder.

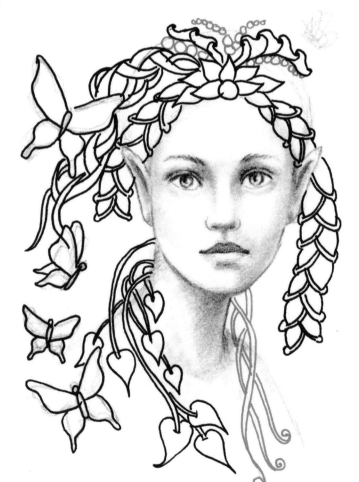

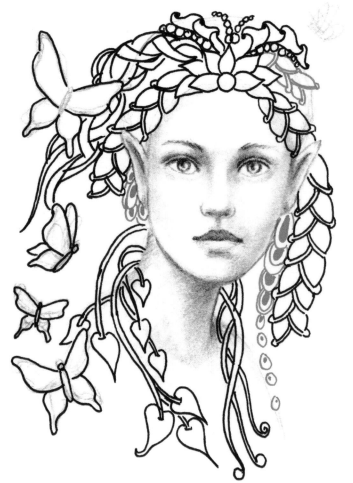

Step 9 Continue to add more tangles as desired. Here I've added another Chainlea and some elongated Mumsy (see inset).

Step 10 Now add some Pokeleaf and Pokeroot "growing" out of the ends of the Chainlea tangles.

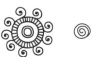

Step 11 Add a bit more Mumsy here and there, as well as a few curved lines and circles to give depth to your tangles. Snail is a great tangle to add dimension behind the vinelike tangles (see inset).

Step 12 Take a breath and look at your tangle. Continue to add fillers and enhancements, as needed. I went back and added some dark seedlike shapes to the base of each Chainlea link. I also drew more Snail tangles and added more lines to the Punzle tangle.

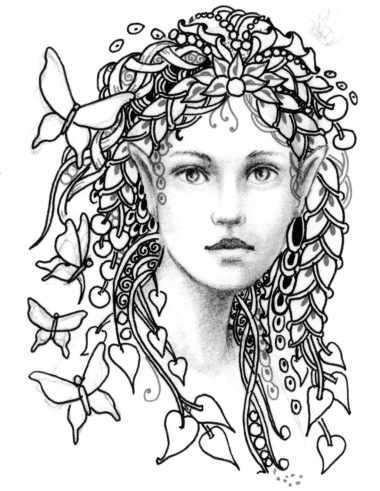

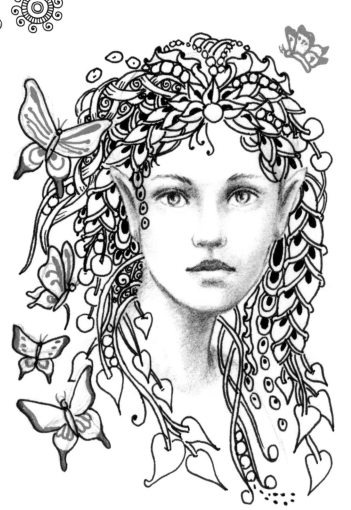

Step 13 When you are satisfied with your fairy, begin to fill in your butterflies with ovals, circles, and lines. Add shading along the edges to give your butterflies depth and texture.

Step 14 Now that you are done tangling, add the finishing touches. Tighten your sketch lines, add the eyelashes, and define any other areas of the face. I used a 005 pen for the eyelashes and to add definition around the eyes. Use a 4B graphite pencil to add soft shading.

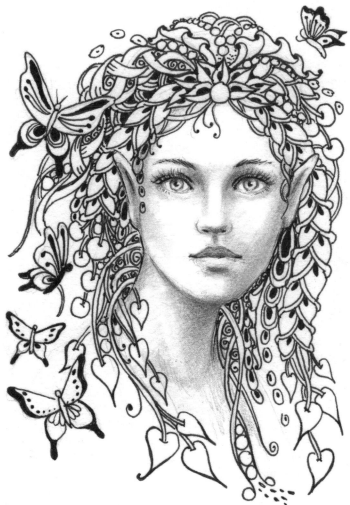

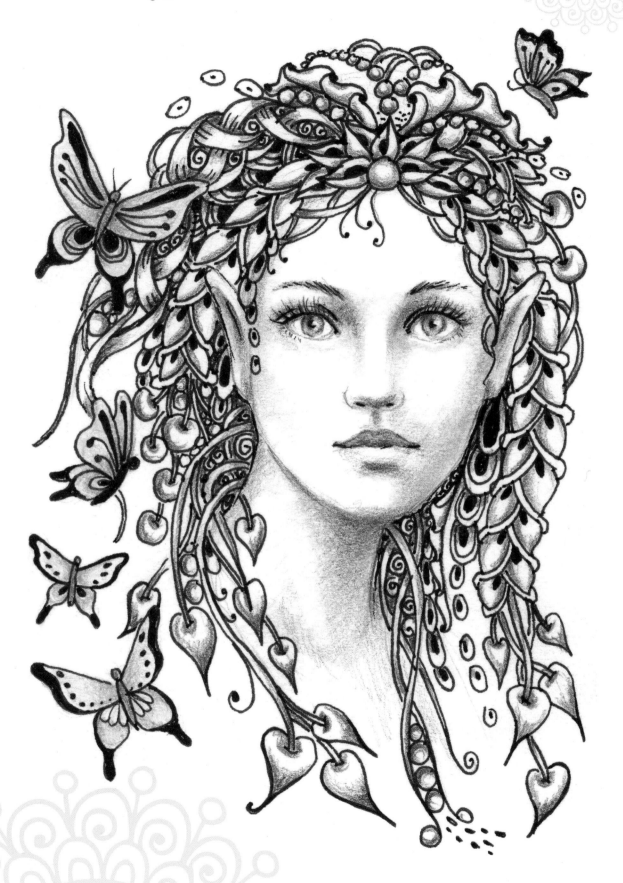

Step 15 Erase any old sketch lines.
Use colored pencils or markers to add
a little color to any areas you like.

ZIA FAIRIES

There is no limit to the types of ZIA fairies you can create. Using the Fairy-Tangles™ below as inspiration, turn to pages 88-89 to practice creating your own fairies. Feel free to combine elements from nature, animals, or any of your other favorite things to personalize your fairy.

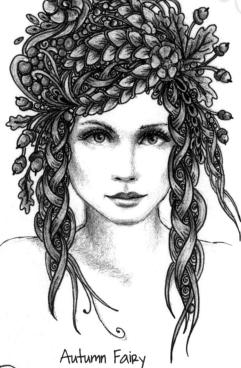

Autumn Fairy

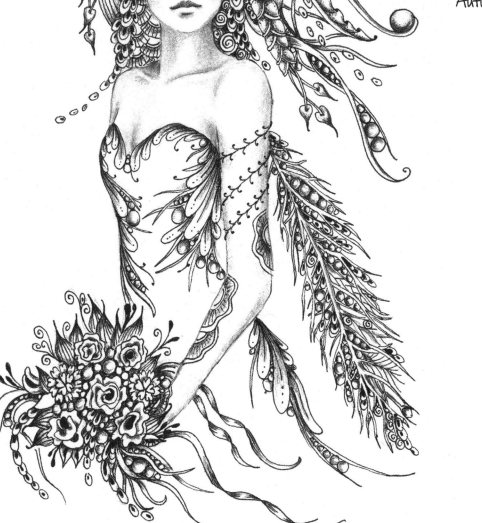

Dragonfly Bride Fairy

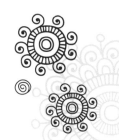

Spring Dance Fairy

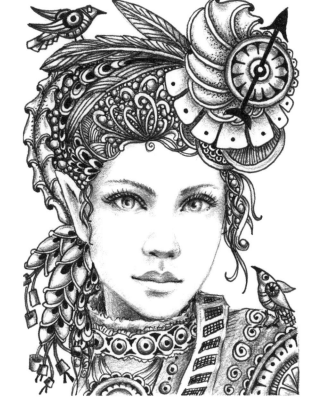

Steampunk Fairy

PRACTICE HERE!

PRACTICE HERE!

ZENTANGLE® MANDALAS WITH MARGARET BREMNER, CZT

I've always loved patterns and details. I had been creating mandalas for about 15 years, mainly in acrylic, when in the winter of 2009, I saw a link on the Internet to "Zendala." Naturally, this piqued my curiosity. Through that link I happened upon Zentangle, and life hasn't been the same since! In May 2010, I traveled to New England to learn about Zentangle from Rick Roberts and Maria Thomas. I also became a Certified Zentangle Teacher. I've been teaching Zentangle and using it in my own artwork ever since. I hope your experience with tangling will be as rich and rewarding as mine has been.

TIPS OF THE TRADE

- **Tip the pen, slant the pencil.** Hold your pen as vertically as possible so that you are always using just the tip. Conversely, hold your pencil at a slight angle so that you don't just use the tip; this will help create softer lines.

- **Shade liberally.** It's really amazing what shading can do for your designs. No matter how lovely your Zentangle® artwork is without shading, it will be even more wonderful with shading.

- **Use tangles in multiple ways.** You can use a single row of almost any square grid tangle for a line or border.

- **Don't discount the power of black and white.** I love color, but I've learned a lot about visual composition from working in black and white. Additionally, black and white is an elegant combination, and it's easy to work with.

- **Stretch!** If your hand gets cramped, you've been in the same "writing" position for too long. Take several seconds to stretch it and relax. Open your hand wide and press gently against a wall or the tabletop.

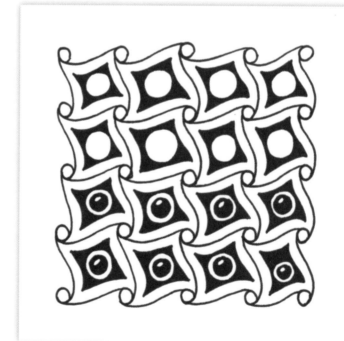

This variation on the basic tangle, Cadent, incorporates the tangle, Black Pearlz.

GETTING CENTERED

I am often inspired by the words of poets, philosophers, and other great minds, especially when I can link their sentiments to my Zentangle mandalas. Below are a few of my favorite quotations. Think about what the words mean to you; then use the practice spaces provided to draw free-form tangles that seem to represent and embrace the ideals presented.

"Let your vision be world-embracing, rather than confined to your own self."

— Bahá'u'lláh, philosopher and mystic

"Until we extend the circle of our compassion to all living things, we will not, ourselves, find peace."

— Albert Schweitzer, physician and humanitarian

"There is, at the surface, infinite variety of things; at the center there is simplicity and unity of cause."

— Ralph Waldo Emerson, poet

PRINTEMPS

Designed by Zentangle® founders, Rick Roberts and Maria Thomas, Printemps is one of the original, official tangles. The word "printemps" is French for "spring," but this tangle reminds me of the intricate designs on Japanese kimonos. Use the opposite page to practice drawing Printemps.

Step 1 Using a pencil, draw an uneven border. Inside the border, draw a single spiral that loops around about four times. Close the design by joining the tail to the next closest line.

Step 2 Add three more spirals around your first spiral, spacing them evenly apart. Each new spiral should touch your center spiral.

Step 3 Next, start overlapping your spirals, adding them in random patterns around the first four.

Step 4 Continue to add spirals until you have filled in the border.

PRACTICE HERE!

PRINTEMPS VARIATIONS

Once you've mastered this basic tangle, you can have fun taking artistic liberties to create endless variations. Use the practice page to re-create these variations or to come up with your own.

▶ I varied the Printemps tangle by creating consistent line breaks in the same general area of each spiral.

▲ To give the illusion of depth to each spiral, add light shading around the outermost edge of each spiral.

TIP
Use the side of a pencil to add shading. To soften the effect, use a blending stump or a cotton swab.

▲ To emphasize the curvy outline of your tangle, add darker shading around the perimeter of the design, blending lightly inward. This shading effect adds dimension to the entire pattern and can be used on a variety of different tangles.

PRACTICE HERE!

CADENT

Based on a square grid, this lovely design with round, curled corners is another official tangle designed by Rick Roberts and Maria Thomas. It's fun and easy to do. Use the opposite page to give it a try!

Step 1 Using a pen, start by drawing five rows of five small, evenly spaced circles.

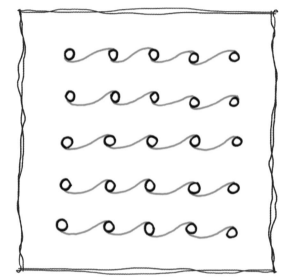

Step 2 Next, join the circles horizontally using a slightly curved line that resembles half of a figure 8. Start your curved line at the bottom of the first circle, curving it slightly upward to meet the top of the next circle. Repeat this until you have connected each circle on every horizontal line.

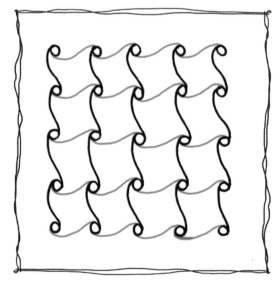

Step 3 Now, rotate your paper once clockwise so that all of the lines you drew in step 2 are vertical. Repeat step 2, connecting all of the circles with curvy lines.

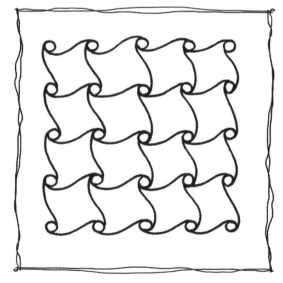

Step 4 When finished, take a moment to admire your work.

PRACTICE HERE!

CADENT VARIATIONS

You can leave the Cadent tangle simple by adding a bit of shading, or you can add elaborate embellishments to make this tangle unique. Most of the variations below can be combined and altered to create other variations. Have fun practicing these on the opposite page, and then try to come up with some of your own!

Feel free to experiment with shading to produce different results.

◀ Fill in each circle with black pen.

Draw an aura inside each scroll-like square.

◀ Draw a curvy square inside each basic square. Next, draw two or three "corners" inside the larger square to create progressively smaller corners. Fill in the smallest square with black pen.

Draw a second curved line directly below the first curved line, and connect the circles.

◀ Draw a circle inside each scroll-like square. Then follow the steps for creating the basic Cadent tangle, drawing curved lines connecting the center circle to each of the four surrounding circles.

PRACTICE HERE!

SHING

Shing is a tangle pattern I designed after having noticed roof shingles while out for a walk one day. Yes, really! Always be on the lookout: Inspiration can come from anywhere! Use the opposite page to practice drawing Shing.

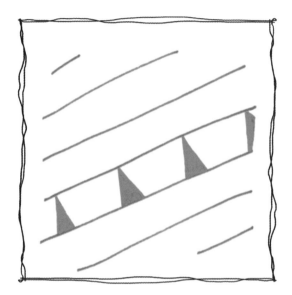

Step 1 Draw several evenly spaced parallel lines; then draw narrow triangles in the open space between two lines. Fill in the triangles with black pen.

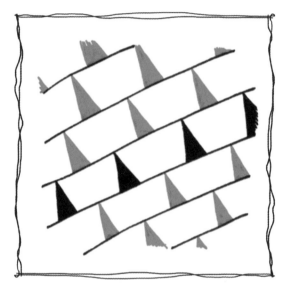

Step 2 Repeat step one in the empty spaces between the remaining lines, staggering the triangles to create a "shingle" type pattern.

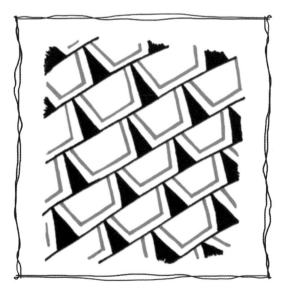

Step 3 Draw a thin border inside each shingle.

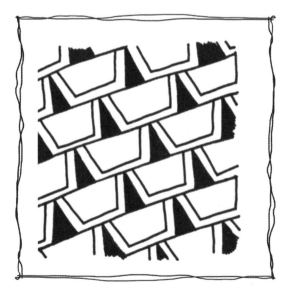

Step 4 When finished, take a moment to admire your work.

PRACTICE
HERE!

SHING VARIATIONS

Feel free to experiment with the Shing variations shown below, or invent a few of your own! Use the opposite page to practice.

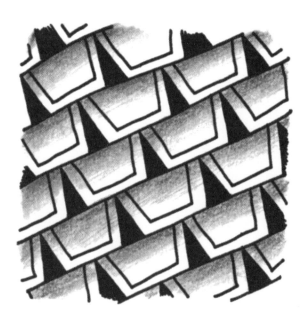

◀ To give your design dimension, add light shading along the tops of the shingles. Use your finger or a cotton swab to blend the shading for a softer effect.

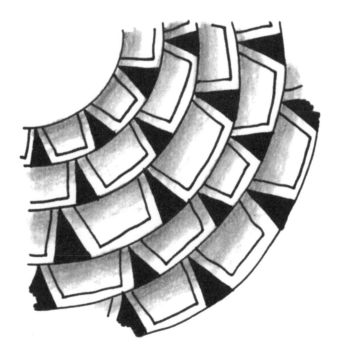

▶ To create a curved variation of Shing, start your tangle by drawing evenly spaced, wide parallel arcs instead of straight lines. Follow the same basic steps; however, keep in mind that the triangles on the innermost arcs will sit closer together, whereas the triangles on the outermost arcs will sit farther apart. You can see in this example how the inner shingles are narrower. From the middle row outward, I adjusted the spacing so they wouldn't be ridiculously wide.

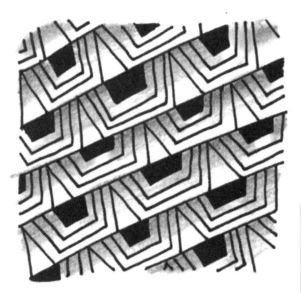

◀ Depending on which elements of a tangle you choose to shade, you can produce myriad variations. To create the variation at left, follow the steps for the basic Shing tangle, but do not shade inside of the triangles. Instead, add three additional borders inside the shingle, drawing each progressively smaller and following the contours of the shape. Darken in the smallest box inside of the shingle and add shading.

TIP
Feel free to experiment with shading, moving from darker shading to lighter shading and back again to see the varied results you'll get.

PRACTICE
HERE!

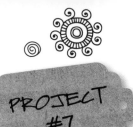

ZENTANGLE® MANDALA

A mandala is artwork created in a circular format with geometrical divisions. This mandala uses the three tangles you just learned in the previous section. Mandalas are intricate and beautiful, and there's much more to them than meets the eye. Review the step-by-step instructions below. When you are ready, turn to pages 112–113 to practice creating your own mandala.

Start with a 3½-inch square of sturdy art paper, which is the same size as the official Zentangle tile. Divide the tile into four imaginary quadrants; then use a pencil to lightly draw four light equidistant dots on imaginary dividing lines, about ⅛ of the way in from the tile's edge.

▶ **Step 1** Now join the dots with arcs. I find that drawing a ¼ of the circle at a time helps keep it nice and round. If you're unhappy with the shape of your circle, use a kneaded eraser to remove your lines and start again. Keep working at it until the circle is how you want it; you'll be working within the circle you've just drawn.

◀ **Step 2** Draw two vertical lines and two horizontal lines to create a grid within the circle.

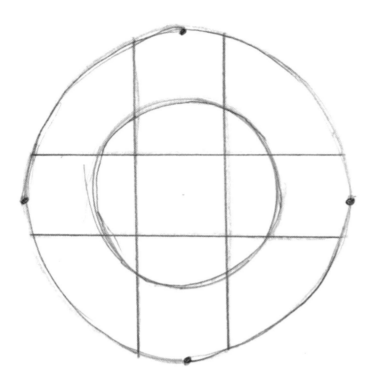

Step 3 About halfway between the outer edge of your circle and the center, draw another circle. This is the pencil string you'll use to create the mini mandala. Now switch from pencil to pen.

Step 4 Fill in the small, square-shaped sections within the outer circle with the Printemps tangle.

Step 5 Following the curve of the outer circle, draw two more evenly spaced arcs in each of the four sections between the Printemps tangles. This is where you'll add the tangle, Shing. When complete, each section should have three separate bands.

Step 6 Starting with one section of bands and working your way around the mandala, draw two wedge shapes inside each band, placing each flush with the Printemps tangle on either side.

Step 7 Now fill in each individual band with Shing.

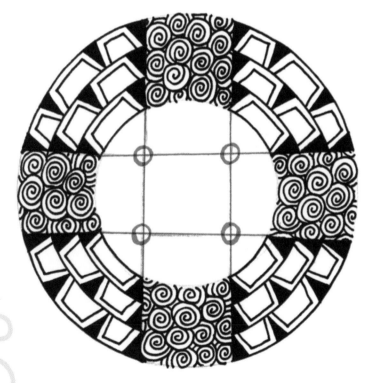

Step 8 With the outer circle filled in with tangles, it's time to turn your attention to the inner circle. Draw one small circle around each of the four pencil-drawn gridline intersections.

107

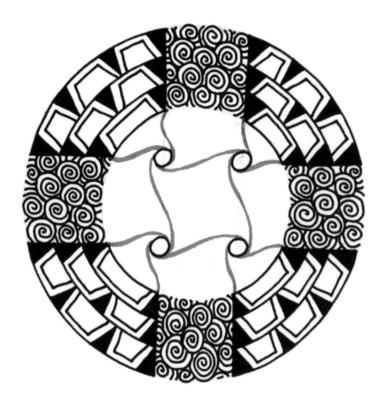

Step 9 Draw a Cadent tangle in the middle of the circle using the four circles as guides. Then draw curvy Cadent-style lines from the inside circles to the lines dividing Printemps and Shing in the outer circle.

Step 10 Add an Aura inside each of the Cadent designs, leaving the four remaining corners empty for now.

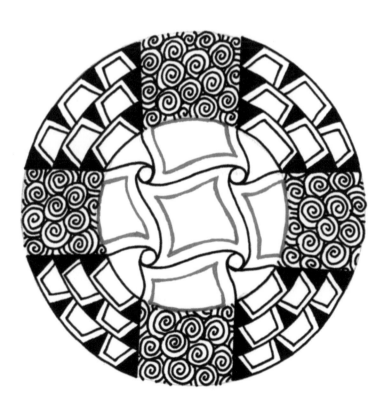

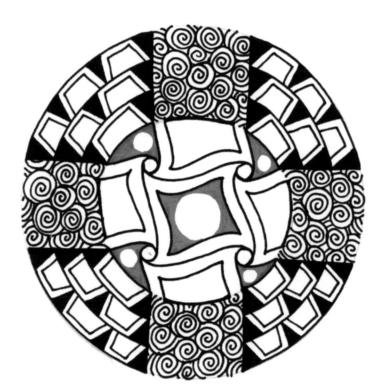

Step 11 Draw a small circle in each corner triangle and fill in the negative space around the circle with ink. Draw a larger circle in the center Cadent square and fill in the negative space around it.

Step 12 Fill in the four additional Cadent patterns with more Auras.

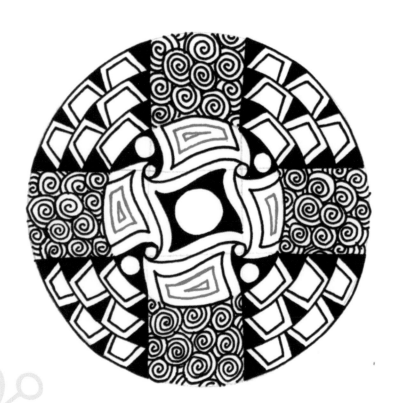

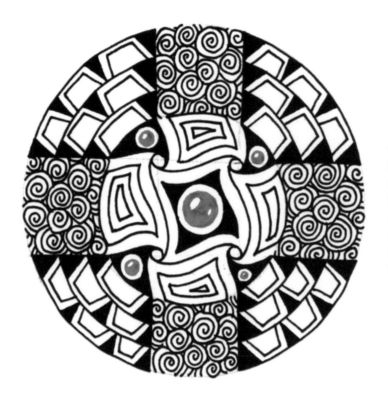

Step 13 Now we'll add the Black Pearlz tangle inside the five small circles. Black Pearlz can be drawn in a row, much like a necklace; however, it's also great for filling in other patterns. Simply draw a circle, add a small oval for a highlight, and fill the "pearl" with ink around the highlight. If your circles are too small, forgo the highlight and just add a black dot.

Step 14 You're done with the ink for now. Put the cap on your pen and get out your pencil. It's time to add shading.

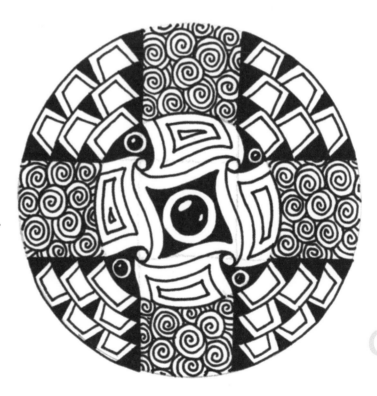

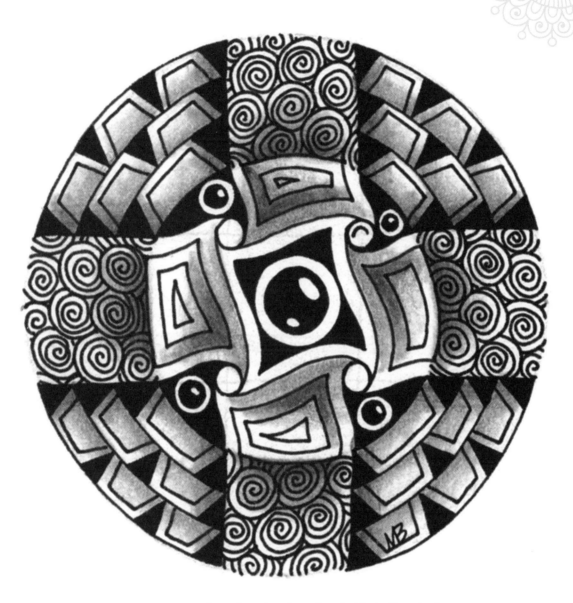

Step 15 Shade Shing along the edges of each shingle. Then shade Printemps around the inner edges. Next, add shading in one corner of each square, or do whatever feels right to you. And *voilà!* You've created a mandala! Don't forget to add your initials.

PRACTICE HERE!

PRACTICE HERE!

MANDALA STENCIL STRING

One day in late 2010, I decided to cut a paper stencil and use it as the string for a Zentangle-inspired mandala. People sometimes cut paper "snowflakes" using this method, although snowflakes have six points and these paper stencils are easier with eight. Creating paper stencils is yet another way to get creative with tangling!

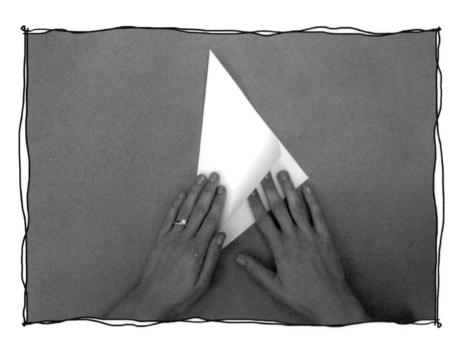

Step 1 Cut a piece of 8½- x 11-inch scrap paper into a perfect 8- x 8-inch square. Fold the paper in half diagonally.

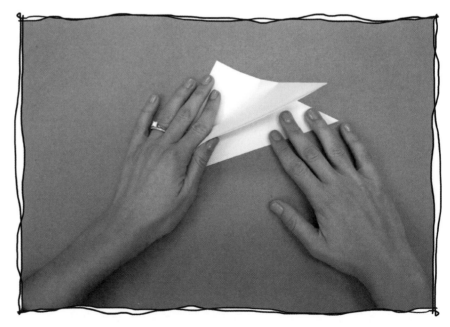

Step 2 Now fold the paper in half again bringing the points to meet each other.

Step 3 Fold each paper point backward on itself (like an accordion), lining up the sides evenly with the rest of the paper. Your paper should be in the shape of a triangle (see inset).

Step 4 With your paper still folded, measure 3 inches in from the center folded point, marking your place on the edges.

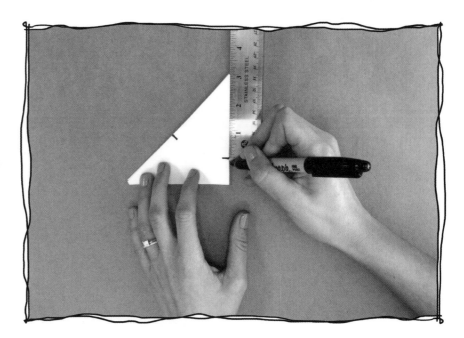

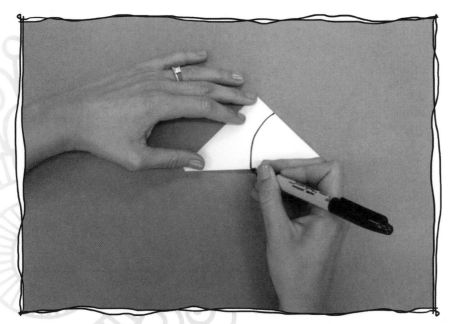

Step 5 Draw an arc connecting the placeholders to form a cut line.

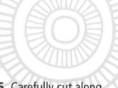

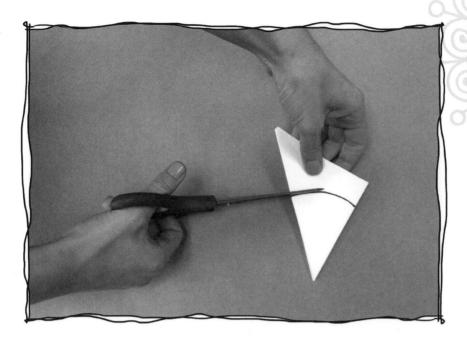

Step 6 Carefully cut along the arc. If you were to open the paper, it would be a circle; however, continue to keep it folded for now.

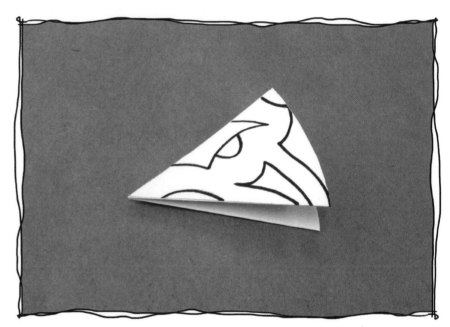

Step 7 Draw a few shapes on your stencil, starting at the edges and drawing them in toward the middle. This is always fun because you never know what you're going to get! You may leave the outer edge as an arc, which will give you a perfectly circular mandala, or you may opt to cut into the arc, which is what I did. Carefully cut the shapes out of your stencil.

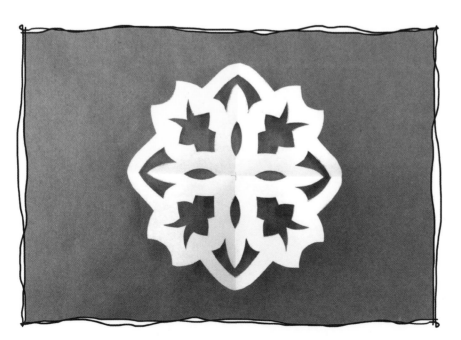

Step 8 Carefully open the stencil. I wasn't expecting the strong square shape but it will be fun to work with. Place the stencil on your drawing paper and trace around it. Connect any open lines to create the mandala shape you like. It's fun to experiment creating different shapes out of a single stencil. I like to use the same stencil several times; the resulting mandalas are amazingly different! On the opposite page, you can see the different mandalas I created using this one stencil.

Below are the four stencil strings I created by adding, subtracting, and moving various pencil lines. To experiment using the strings below, scan this page and enlarge the templates on your computer before printing them out.

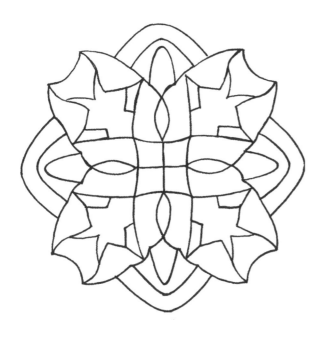

Below are the results of the mandalas I created from the different stencil strings shown on page 117. Notice the variety of each one!

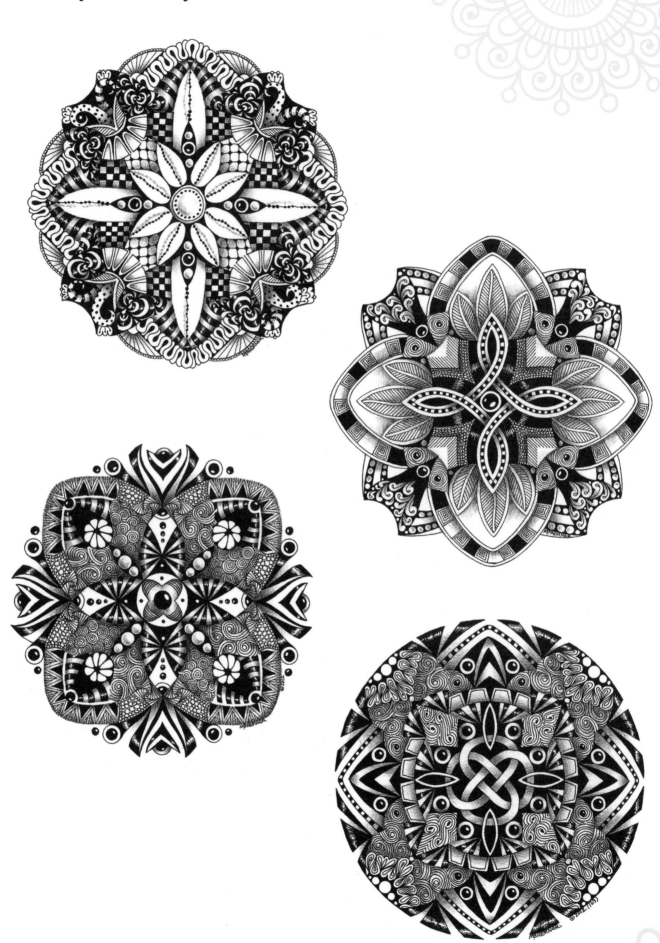

To practice using the original stencil string from this project, trace the template below. Then tangle it to your heart's content!

TANGLING OUTSIDE THE BOX WITH LARA WILLIAMS, CZT

I first discovered Zentangle® in 2004 when its founders, Rick Roberts and Maria Thomas, introduced the art during a large management meeting "ice breaker." Watching more than 50 of my coworkers focus intently on their artwork and forget about their workday simply amazed me. I was hooked instantly. From that moment forward, I started sharing my joy of Zentangle with anyone who would listen. I even found ways to share it at my current workplace. I have worked in the mental health field for many years, and I wanted to share the benefits I received from practicing Zentangle with others. When the Zentangle Teacher Certification was offered, I jumped at the chance. I've been teaching and tangling ever since. A longtime crafter, I now incorporate my Zentangle inspirations into almost everything I create. I also see the world around me as patterns and strings. Zentangle® has been an inspiration and gift in my life, and I hope you find as much comfort, creativity, and fun practicing as I do.

TIPS OF THE TRADE

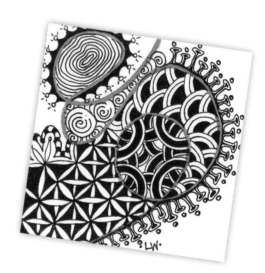

- **Use real string.** If you can't think of a string, use actual string! Keep a piece of string or thread handy, and let it fall onto your tile. Trace it and you're good to go!

- **Be Zen.** A Zentangle is meant only to be a Zentangle—there is no up or down, right or wrong. Just enjoy the process.

- **Experiment.** Use a large-point pen to fill in larger areas with all black. For added interest, try tangling on black with a white gel pen.

- **Organize your tangles.** I organize my tangles into four categories to keep track of them: borders, grids, shapes, and filler. This helps me find a tangle to fit the space when I am unsure what to use.

CREATING STRINGS

Once you start tangling, you begin to notice all of the patterns around you everywhere you go. From rugs to buildings to lampposts, tangles are all around us, but what we don't often look for are the strings. When I am out walking, I often stumble upon the most amazing strings. It gets me excited to rush home and start tangling! The next time you are out in your neighborhood (or even walking around your own home), take a closer look to see what strings you can find to start your next tangling adventure!

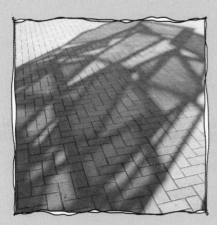
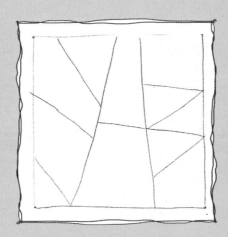
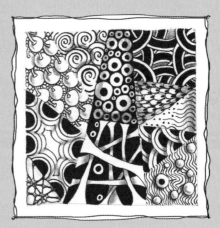

This beautiful geometric reflection of a sculpture in downtown Indianapolis became my inspiration for the Zentangle above.

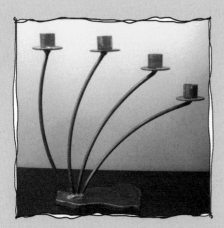

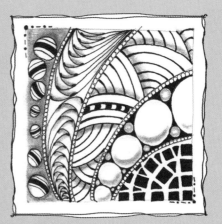

Here is a string I found on my bookcase! I love the curves of this candlestick holder.
I simply transferred the lines of the shape to a tile and started to tangle.

POPPET

I created Poppet, which is a great tangle on its own, but it also lends itself nicely as filler for other tangles. Use the opposite page to try it out for yourself.

Step 1 Make a small dot; then draw evenly spaced teardrop shapes around it, with the tip of the teardrops pointing in toward the dot.

Step 2 Draw another layer of evenly spaced teardrops around the first set, making them slightly larger.

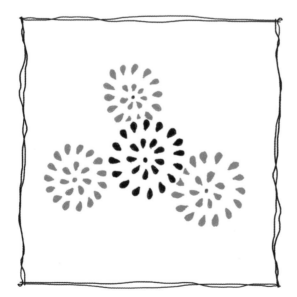

Step 3 Follow steps 1 and 2 to create additional Poppets in a random pattern. To give the illusion of overlapping Poppets, draw only part of the teardrops, for a "cut off" look.

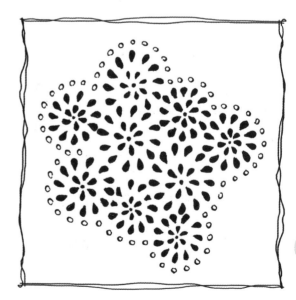

Step 4 Add a hollow-circle border around the entire design.

PRACTICE
HERE!

POPPET VARIATIONS

Here are some fun variations on Poppet. Use the opposite page to practice them, or create some variations of your own.

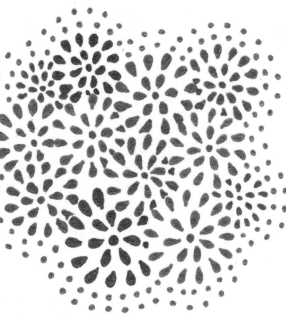

Poppet is especially fun when it's in color. I used bright, sparkly gel pens in this example. Use a different color for each one to create a beautiful garden!

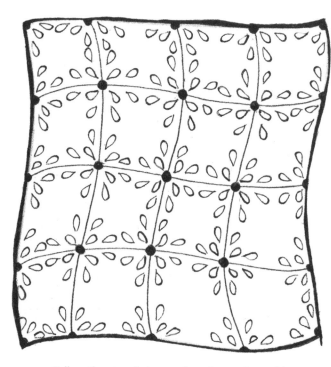

Follow the steps below to draw Poppet in a grid.

Step 1 Start by placing center dots on the meeting points of the grid.

Step 2 Place one teardrop shape in each corner of the grid section, with the tip pointing inward.

Step 3 Add the next layer of teardrop shapes around the first four.

Step 4 Continue the process until you fill in all of the grid sections.

PRACTICE
HERE!

ZIPPEE!

I created Zippee! from a picture in a magazine that had different fun fabric patterns. My friend gave me the page and told me she thought the fabric looked like Zentangle® patterns. I kept the page for a while, then one day I got out my pencil and Zippee! was born. Give Zippee! a try on the opposite page.

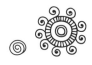

Step 1 Draw five short vertical, evenly spaced lines in a row across the top of your tile. Add a second row, staggering the lines so that they are not perfectly aligned with the row above. Continue this process to fill in the tile.

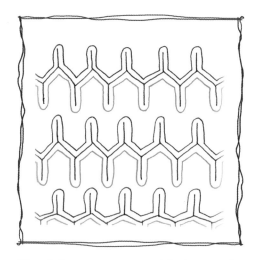

Step 4 Draw an aura around the bottom of each segment.

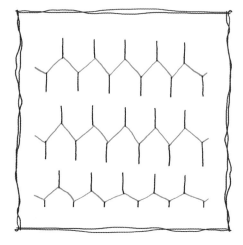

Step 2 Draw slanted lines connecting the lower points of the vertical lines in row one, with the top points of the vertical lines in row two. Do not connect the second and third rows, but repeat this process for rows three and four and five and six.

Step 3 Draw an aura around the top of each connected segment. An aura is a line that closely parallels another line, following its shape.

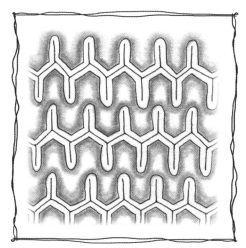

Step 5 Complete your Zippee! tangle by adding a bit of shading to finish.

PRACTICE HERE!

ZIPPEE! VARIATIONS

Below are some fun variations on Zippee! Use the opposite page to practice these or to create your own.

Try varying the distance between the rows of your lines, changing their length or adding larger dots in the spaces between your lines. You can also use shading to shape the outline of your border.

Combine your tangles to create variations. Here I merged Zippee! with Poppet for a unique, layered combination.

TIP
Don't forget to turn your tile as needed when drawing. You can flip it upside-down, sideways, or whichever way feels comfortable to create the best line that you can.

PRACTICE HERE!

TWINK

Twink became a possibility when I created the steps for Zippee! because it starts off with the same basic step. I had seen hexagon-shaped designs, but I wasn't quite sure how to get there in an easy, step-by-step fashion. With the foundation created by Zippee!, the steps to Twink create a beautiful quiltlike pattern that has so many embellishment possibilities, it's easy to make it your own. Try it out on the opposite page.

Step 1 Start Twink in the same way that you began Zippee! (See page 126.)

Step 2 Use slanted lines to connect the bottom of the first row to the top of the second row. Repeat this for the entire pattern, creating hexagon shapes.

Step 3 Now draw a circle in the center of each hexagon.

Step 4 Draw lines leading out from the circle to each corner of the hexagon. You should have six in total.

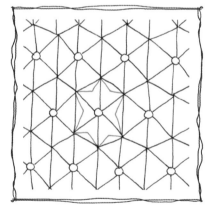

Step 5 Next, draw a shallow "V" shape between the adjacent corners of each panel within the hexagon to create a star shape. Repeat until you have filled in the tile.

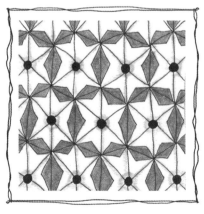

Step 6 Add shading around each star and fill in the circles with solid color.

PRACTICE HERE!

TWINK VARIATIONS

Below are some unique variations on Twink. Use the opposite page to try them out for yourself!

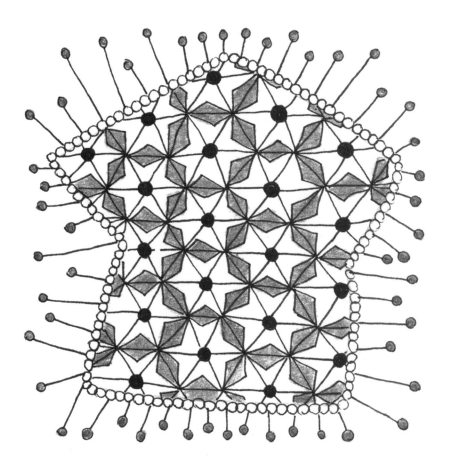

Adding funky borders and embellishments to your Twink tangle can make for fun and interesting results!

Adding more "divider" lines within the hexagon shapes will yield more points. Try using a color pencil or pastel crayon to add color shading for more dimension.

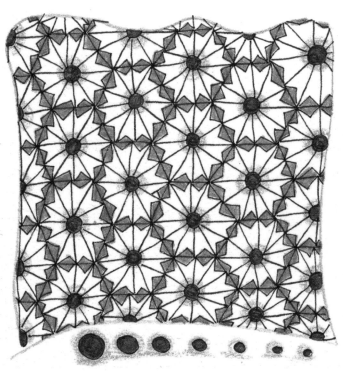

PRACTICE
HERE!

GLITTER TANGLES

Glitter tangles are fun to design and relatively easy to do! They also make for funky wall art and wonderful personalized gifts!

Tools and Materials:

- 2 colors of glitter (one for the tangles, one for the background)
- White glue
- Mini squeeze bottle with lid and small opening
- Drawing pencil
- Stretched canvas (I used 8" x 8", but you can choose any size you like)
- Large sheet of scrap paper to protect your work surface
- Soft paintbrush
- Small paintbrush for glue
- Paper towels
- Acrylic sealer (clear gloss)
- Rhinestones (optional)

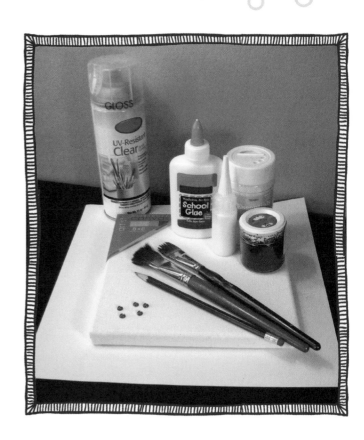

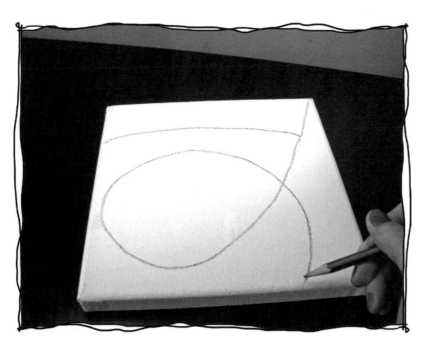

Step 1 Start by lightly sketching a string on your canvas with a pencil—just like you would on a tile.

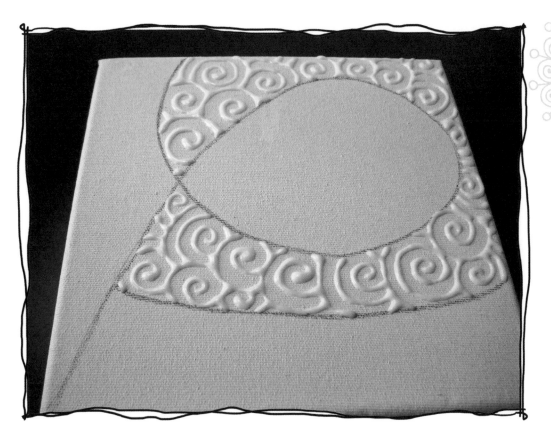

Step 2 Place your large scrap paper beneath your canvas to protect your work surface. Add a little bit of the white glue to your mini squeeze bottle and secure the lid tightly. Using light pressure and starting in one section of the string, squeeze the bottle of glue and begin "drawing" your tangle on the canvas.

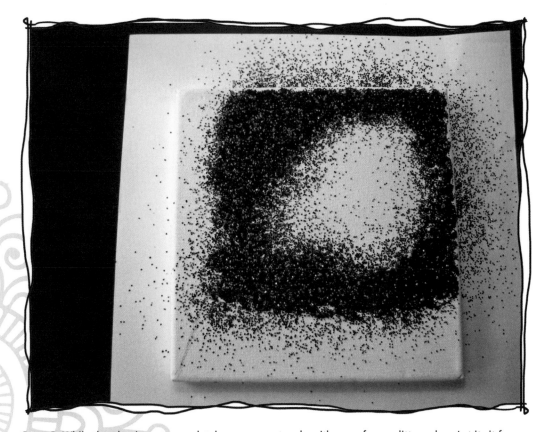

Step 3 While the glue is wet, completely cover your tangle with one of your glitter colors. Let it sit for a few minutes; then lightly shake off the excess glitter onto your sheet of scrap paper for reuse. Allow the canvas to dry flat for 2 to 3 hours or overnight.

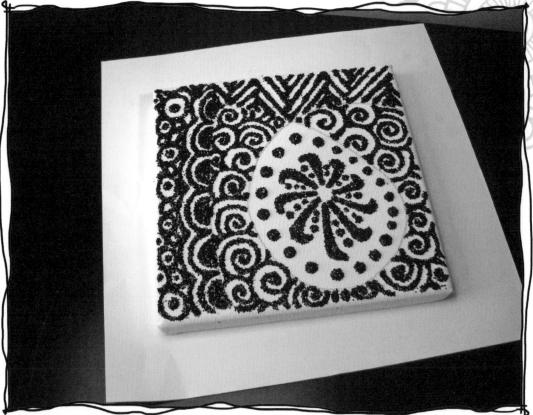

Step 4 Once dry, lightly brush over the canvas with a soft paintbrush to remove any residual glitter. Repeat steps 1 through 3, adding in more tangles in the remaining sections until you have filled the entire canvas. Let dry completely.

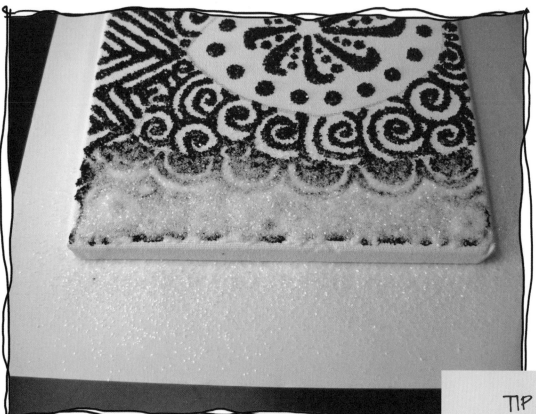

Step 5 Using light pressure, squeeze glue from your mini bottle in the empty spaces between your tangle patterns. While the glue is still wet, sprinkle the second glitter color over the entire section, making sure to cover the wet glue completely. Follow the same process outlined in steps 3 and 4 until you've covered all of the empty spaces on your canvas. Allow to dry.

TIP
For large canvases, you may wish to complete step 5 in small sections.

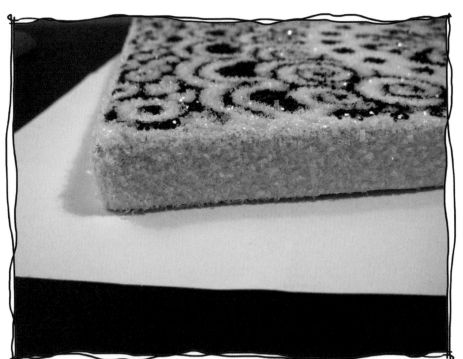

Step 6 Brush a thin layer of glue on one side of the canvas. While the glue is still wet, sprinkle a generous amount of your second glitter color on the entire area. Allow the canvas to sit for a few minutes and then shake off any excess glitter. Repeat the process on all four sides of the canvas. Allow to dry completely.

TIP
Keep a damp paper towel handy for easy glitter clean up while you work.

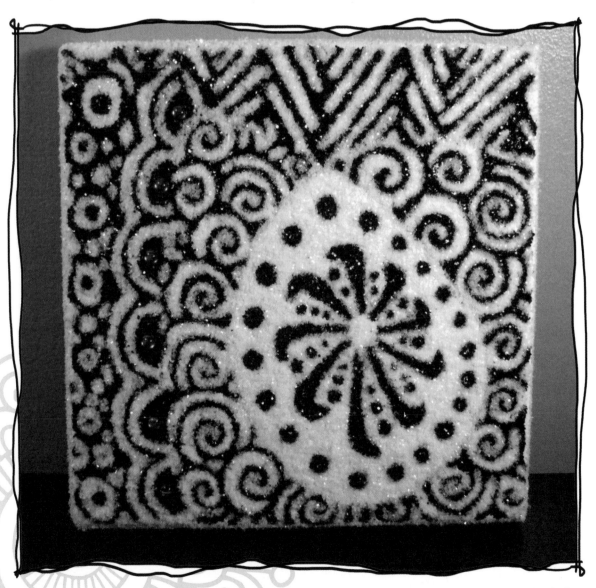

Step 7 For a little extra pizazz, lightly dot select areas with glue and apply rhinestones. When your piece is completely dry, spray it with a clear gloss acrylic sealer to preserve it. Use the practice areas on pages 138-139 to work out your glitter tangle ideas.

PRACTICE HERE!

PRACTICE HERE!

TANGLED FRAME

Tangles are perfect for embellishing all sorts of fun items—from shoes to frames. This project is so easy, you'll want to make more than one. For this frame, I used the original tangles® Pokeleaf, Tipple, and Fescu.

Tools and Materials:
- Unpainted wooden frame
- Acrylic craft paint in one or more colors
- Drawing pencil
- Fine-point paint pen
- Medium-point paint pen
- Small paintbrush
- Acrylic sealer (clear gloss)

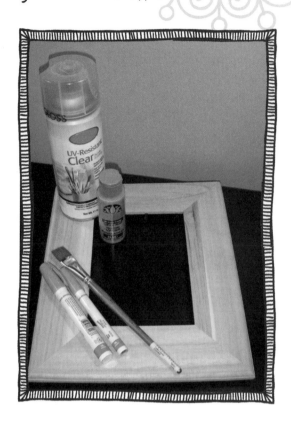

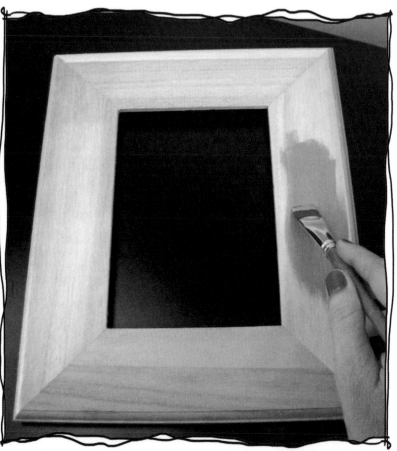

Step 1 Start by painting the frame in the color or colors of your choice. Allow it to dry completely; then add a second coat, and allow it to dry completely.

Step 2 Using your fine-point paint pen, start in one corner of the frame and draw the tangles of your choice. Fill in larger areas with the medium-point paint pen.

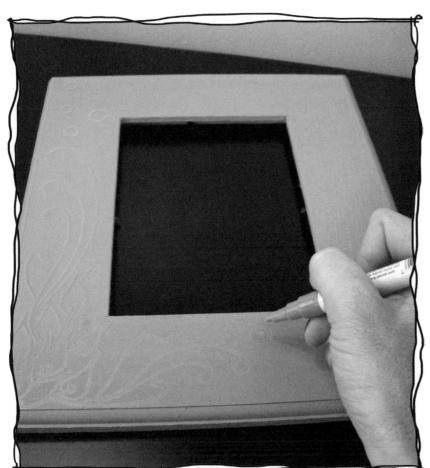

TIP

To keep your paint pen flowing, press down on the tip on scrap paper every so often. Never press the tip of your pen directly on your project or you may end up with an unwelcome paint blob.

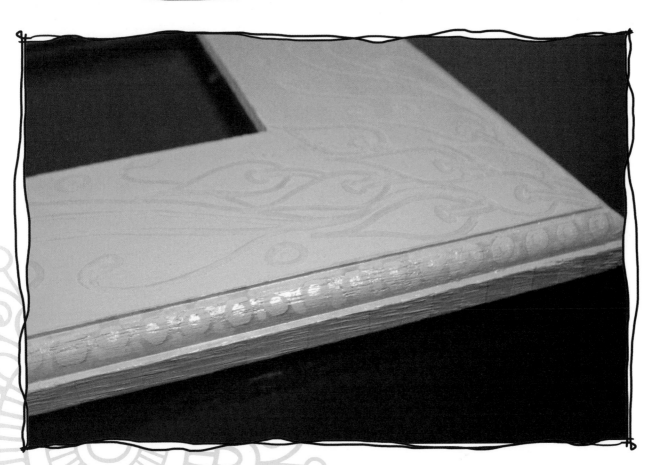

Step 3 Continue adding tangles to the frame until you are satisfied with the results. Don't forget to add enhancements and/or borders to the sides, which is a great place for fun additions that will really make your frame stand out. Allow the frame to dry completely. In a well-ventilated space, lightly coat your frame with acrylic sealer. Choose a gloss sealer for shine.

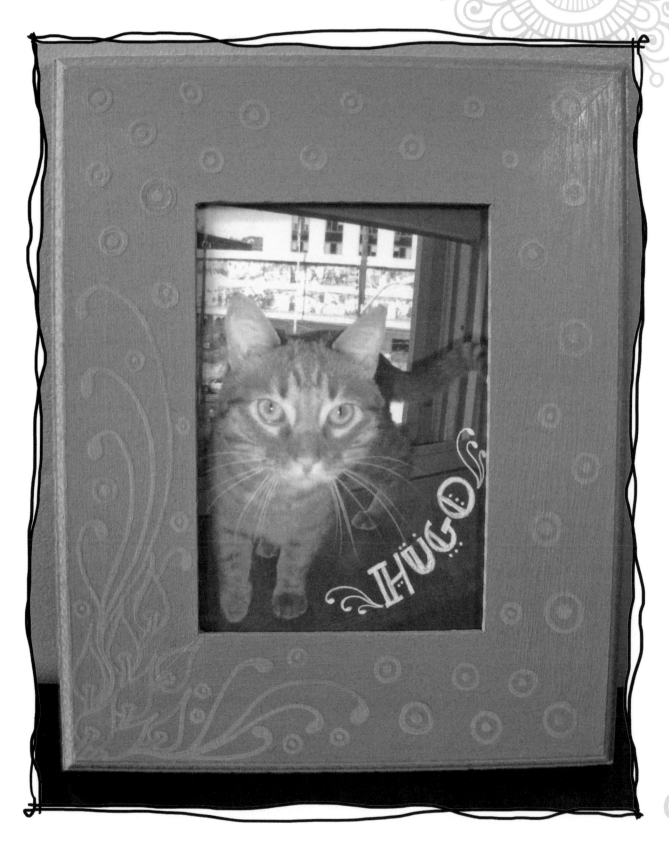

Step 4 Insert your favorite photo in your frame. Now you have a beautiful tangled showpiece!

Use the practice space below to work out your frame tangle ideas.

ABOUT THE ARTISTS

A lifelong art lover, Certified Zentangle® Teacher **Margaret Bremner** earned a BFA from the University of Saskatchewan in 1977 and has exhibited in Canada and the U.S. With intricate detail, elegant craftsmanship, and whimsy, Margaret works in various media. She frequently incorporates tiny gems, brads, or metal disks into her work, and she has been creating mandalas for almost 20 years. Margaret has completed numerous commissions for businesses and individuals; her illustrations have appeared in many magazines; and she has taught drawing, painting, calligraphy, and Zentangle® to children and adults. Raised in Saskatoon SK, Margaret has previously lived in Quebec, Ottawa, and China. She often wonders where she will end up next. Visit www.enthusiasticartist.blogspot.com.

Norma J. Burnell, CZT, is an accomplished artist and has been involved in the arts all of her life. She has had years of formal training in the classical arts, focusing on drawing and painting, and has also has taught art and jewelry making to adults and children. Norma has won several People's Choice awards for her Fairy-Tangles™ Artist Trading Cards and received her Zentangle® Teacher Certification in October 2011. A Web Services Manager for a full-service advertising agency in Newport, Rhode Island, Norma enjoys being a total computer "geek," as well as biking, swimming, and gardening. She resides in the seaside community of Jamestown with her husband and two cats, Puck and Loki. Visit www.fairy-tangles.com for more.

A "maker of stuff," Certified Zentangle® Teacher and artist **Penny Raile** is known for her whimsical projects that range from cardboard cuckoo clocks to WhimBots crafted from thrift-store finds. Her downtown Los Angeles loft with its turquoise-stained floor and hand-painted walls reflects an eclectic mix of paintings, sewn dolls and creatures, polymer clay objects, and dioramas. Her drawers are full of found objects waiting to be turned into arms or legs for her newest creation. The bookcases are full of art books and journals she has filled with her own drawings and collages. Penny loves color and things that make people smile. She brings her special brand of creativity to all of her professional pursuits, including her many years in fundraising and development for nonprofit organizations. Her projects and events have delighted countless children for whom art is a rare experience. Visit www.tangletangletangle.com and www.raile.typepad.com.

Lara Williams, CZT, is a mixed media artist and crafter. She became a Certified Zentangle® Teacher in 2009 and has developed workshops for the general public, as well as individuals recovering from mental health issues. Lara has explored many different mediums and crafts, including jewelry making, carving her own stamps, drawing, and painting. She enjoys blogging and developing new Zentangle® patterns. She lives in Indianapolis, Indiana, with her fiancé Ned and their cat, Hugo.